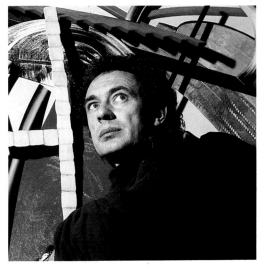

Peter Phillips in his studio, Zürich, *1982*
(photograph © Birrer)

*retro*VISION
Peter PHILLIPS
paintings 1960-1982

An exhibition organized by the Walker Art Gallery, Liverpool,
Merseyside County Council,
with subsidy from the Arts Council of Great Britain

ISBN 0 901534 80 3

Published 1982 by the Walker Art Gallery, Liverpool,
Merseyside County Council, for an exhibition organized
with subsidy from the Arts Council of Great Britain
© Walker Art Gallery 1982
All reproductions of works by Peter Phillips © the artist
Text © Marco Livingstone 1982

Catalogue designed by Malcolm Garrett / Assorted iMaGes
Artwork by Steven Appleby
Printed by The Hillingdon Press, Uxbridge, Middlesex, England
First edition 3500 copies
Photoset in Compugraphic Helios II
Printed on white matt art 135gm²
Cover printed on Hi-Speed Blade board 280gsm

PHOTOGRAPHIC CREDITS

courtesy the artist
Birrer
Galerie Bischofberger, Zürich
Brompton Studios, London
A. C. Cooper Ltd., London
Kornblee Gallery, New York
J. S. Lewinski, London
Galerie Neuendorf, Hamburg
Eric Pollitzer, Garden City Park, New York
Studio Roland Reiter, Zürich
Réunion des musées nationaux, Paris
The Tate Gallery, London
Rodney Todd-White & Son, London
John Webb, London

Walker Art Gallery, Liverpool
26 June – 1 August 1982

Museum of Modern Art, Oxford
15 August – 3 October 1982

Laing Art Gallery, Newcastle-upon-Tyne
15 October – 21 November 1982

Fruit Market Gallery, Edinburgh
22 January – 26 February 1983

Southampton Art Gallery
20 March – 8 May 1983

Barbican Art Gallery, London
1 July – 4 September 1983

PREFACE

The work of Peter Phillips, one of the originators of Pop Art, has been little seen in Britain since 1964, when he left this country for what has turned out to be an extended period abroad. During this time Phillips has quietly pursued his personal vision, already established in the early 1960s, elaborating with great inventiveness and unwavering commitment the strongly-defined imagery, surprising juxtapositions and refined techniques which together distinguish his art.

A retrospective was held in Germany in 1972 and a substantial monograph covering Phillips's paintings, drawing and prints was published in 1977. In Britain this exhibition is the first opportunity to study the entire range of the artist's paintings over a period of more than two decades. It is with great pride that the Walker acts as host to this event, the third in our series of retrospectives of British painters in mid-career, following on from our very successful Allen Jones and Patrick Caulfield exhibitions in 1979 and 1981.

As on previous occasions, the very generous financial support of the Arts Council of Great Britain has helped make this project a reality. I am indebted also to the other galleries taking part in the tour, as their enthusiastic support will make it possible for this exhibition to be seen by very many people all over Britain.

The generosity of the lenders has been exceptional, as they have had to part with their paintings for more than a year. In particular I wish to thank Hans Neuendorf of the Galerie Neuendorf, Hamburg, for lending the large group of major works, without which this exhibition could not have taken place.

Marco Livingstone, Assistant Keeper of British Art at the Walker, has organized the exhibition with the same attention to detail which distinguished his Allen Jones and Patrick Caulfield shows. I should like to thank him for bringing his usual energy and expertise to the task.

John McEwen, art critic of *The Spectator,* has kindly written an introduction to the catalogue to complement Marco Livingstone's critical analysis. I am most grateful to him for finding time in his busy schedule to lend us his support. I should also like to thank Malcolm Garrett for creating the excellent and sympathetic design of the catalogue and publicity material.

We have had Peter Phillips's enthusiastic support and tireless involvement with every aspect of the exhibition. He has helped draw up the list of works, trace their location and secure key loans; discussed frankly with Marco Livingstone about the development of his work; and been involved with Malcolm Garrett over the design of the catalogue and publicity material. In addition, he has lent a great number of colour transparencies for use in the catalogue, and he and his wife have parted with some of their most prized pictures. Peter Phillips has done everything in his power to help us make this exhibition a success. To him I owe my deepest thanks.

Timothy Stevens
Director,
Art Galleries Department,
Merseyside County Council

ACKNOWLEDGMENTS

I should like to thank the following people for their help with my research:

•Alan Bowness and John Golding for their support in the initial stages of my work on British Pop Art;
•Derek Boshier, Patrick Caulfield, David Hockney, Allen Jones and R. B. Kitaj for graciously consenting to be interviewed over the years in connection with their period as students at the Royal College of Art;
•Gerald Laing for generously supplying written answers to a questionnaire concerning his collaboration with Phillips on the 'Hybrid' project;
•Trevor Halliday for providing information concerning the artist's training in Birmingham;
•Christopher Taylor for kindly allowing me to quote from letters written to him by the artist in the early 1960s;
•Sarah Fox-Pitt at the Tate Gallery Archives for granting me permission to quote from Pat Gilmour's unpublished 1975 interview with the artist;
•Hans Neuendorf, Nicholas Tooth, Peter Cochrane, the Wadding Galleries (Louisa Mair and Henrietta Chamier), the British Council (Muriel Wilson) and the Royal College of Art (Gillian Patterson and Barbara Treganowan) for their help in tracing paintings and in locating photographs;
•and Malcolm Garrett for his thoughtful and energetic work in designing the catalogue.

My greatest debt is to Peter Phillips himself, for not only submitting so patiently to several lengthy interviews over the past six years, but also for giving so unstintingly of his time in the planning of every aspect of the exhibition.

Marco Livingstone
Assistant Keeper of British Art,
Walker Art Gallery

LENDERS TO THE EXHIBITION

The *artist*
Albright-Knox Art Gallery, Buffalo
Bruno *Bischofberger Gallery, Zürich*
Calouste *Gulbenkian Foundation, Lisbon*
Lindenmeyer collection
Hans *Looser*
Dr. R. *Müller*
Galerie *Neuendorf, Hamburg*
Oldham Art Gallery and Museum
Claude and Zoé *Phillips*
O. R. *Triebold*
Waddington Galleries, London
Walker Art Gallery, Liverpool
Galerie *Ziegler, Zürich*
and numerous private collectors who prefer to remain anonymous

INTRODUCTION

In America I once eavesdropped on an adult education group huddled at the feet of a teacher explaining a painting by Matisse. 'OK', said the teacher, 'somebody tell me what they see in this picture.' It was very large, of a boy in a room, playing a piano - the 'Music Lesson'. 'Come on', she urged, looking hopefully for a response, 'you must see something!' 'The chip on his face', a voice finally ventured, 'the black mark on his face?' 'You see the "chip on his face"?' Exclaimed the teacher. 'This little triangle here? What's the matter with you guys! Can't you see the piano, the window, the little boy! The "chip on his face"!' And she shrugged her shoulders in mock despair. As a critic I am bound to ask myself the same question of Peter Phillips's pictures: what do I see and, by extension, why do I like what I see. The answer may well be as provoking to you as was the response to Matisse for the teacher, but that will be unavoidable because there is no true answer. You can read all the books in the world, but you still confront a picture with your own eyes and in the light of your own nature and experience.

Peter Phillips's pictures first caught my attention in the Sixties because they were so totally to do with city life - not a blade of grass to be seen, everything unapologetically man-made; pin-ball machines, pin-ups, the stuff of an ordinary day and ordinary experience. In a very English way I had been taught to look for a lofty moral purpose in painting, and here, mercifully (even a bit shockingly), were pictures with no holier-than-thou undertones, no snooty pretensions at all. They did not disapprove of advertising or bikes or pin-ball machines. They just accepted them as part of life, therefore, if one so chose, of painting too. What a relief.

I like the rough collage element in the earliest of Phillips's pictures, things just glued on without too much bother. It suits the carefree mood. Collage is derived from play. It was first used to keep school-children imaginatively employed back in the 1830s and Picasso introduced it to art precisely because he believed painting and sculpture should be playful, at least in part. Playfulness, for me, comes through in much of Phillips's art, right to the present. It is certainly very much there in the 'Custom Paintings'. They were done at the height of the most swinging time of the Sixties, and seemed appropriately extreme: no friendly 'hand-made' surfaces any more, and jazzy with all those zig-zags. Immediately identified as rocker art, they were for hard-liners who preferred Lennon to McCartney, Dylan to the Kingston Trio. Today they do not seem so hard, and yet at the same time they are more interesting. 'Electronics' was hardly a dictionary word in the Fifties, but here it seems, perhaps for the first time, symbolised in a picture. And, of course, from the vantage point of middle-age their youth and zest appear all the more obvious - and enviable.

The 'Random Illusion' series came along at about the time that it was still quite smart to know the meaning of 'ecology'. They have more of a message, less impact, and for me an ecological one at that - birds of prey peck and perch on car entrails. The ironic permutations would keep a computer running till doomsday; especially as these are not just any birds of prey, but stylisations of the ones in 'The Birds of America' by the first great naturalist of that continent, John James Audubon. But what black beauties 1 - 5!

Phillips next explored size. Mind-blowing distances were part of everyone's awareness at this moment of the moon landings. Is the weightlessness of these machine-parts a further lunar influence? I prefer the experiments with technique in these pictures - the way colours fade indivisibly - more than the overall image, however subtly in touch with its time, though maybe seeing them again (illustrations are particularly uninformative) will reveal something more in their dizzying spatial shifts. Textures are also faithfully and minutely imitated - an imitation of imitation leather: as much a pun, an inside-out, as their titles; and cars have never had such a sexy going over. All art is erotic, said Picasso again. So, I suppose, is anything intricately done with fingers. Yet people say painting is dead when, sublimated, elevated or not, artefacts are surely the immemorial and ultimate sex object.

Detail has brought Phillips back to oil pigments and brushes and away from acrylics and spray-cans in the last few years. Today he prefers relatively plain paint and canvas to the wonderfully mixed assemblages of the early Seventies. In the latest pictures the imagery is fragmented and he plays tricks with real and imitated relief. The playfulness, the extremism, the directness, the open-mindedness are all still there, only refined. I find these paintings as satisfying as any he has done. They throw further light on the logic, the long single-mindedness, of his purpose; and through them one admires, and sees, the magnitude of his overall achievement - viewed in this way his work also reveals a continual awareness and deepening knowledge of other painting, but that is for the punters. In 1964 he wrote: 'I'm basically interested in painting and not just in presentation of imagery'. He still is, only more so: his life - the people and things he loves and likes: his wife, his pets, his plants, certain textures, certain colours - is his art. Nothing is disregarded. A Wurlitzer juke-box, stacked with old 78's, remains a prize possession. I like that too.

John McEwen

PETER PHILLIPS

Marco Livingstone

The Pop paintings produced by Peter Phillips during the 1960s, large in scale, brilliant in colour and polished in finish, today seem to encapsulate that era, and they have lost none of their formal or emotive power over the years. Bold and aggressive in conception, even the earliest paintings, executed when the artist was barely in his twenties as a student at the Royal College of Art, startle today with their directness of impact.

At a time when many artists were flirting with modern technology, Phillips immersed himself wholly and without apology in the machine aesthetic. His range of images - whether of automobiles, machine parts, predatory animals, pin-ups or scientific diagrams - was drawn exclusively from readily-available printed sources, mass-produced, cheap and familiar to anyone living in this society. Phillips's techniques and compositional methods, likewise, were appropriated from commercial art and from industry, not just in his use of the airbrush for an anonymous perfection of finish but in his habit of recycling images from one painting to another as if they were the interchangeable parts of a modern machine produced by assembly-line methods.

Over the past two years a radical change has taken place in the appearance of Phillips's paintings. The 'Pop' label sits uneasily with them. Big enough for the artist to 'move around in' but less over-powering in scale than the canvases of a decade ago, these are colour fields, painted with conventional brushes rather than with an airbrush, against which are disposed isolated fragments of dimly recognizable but enigmatic images such as animal skins. The dazzling colours of Phillips's previous work have given way, for the time being at least, to more subtle and sombre hues. The surface, though still tightly controlled, no longer aspires to a machine-like perfection and anonymity, but instead bears traces of the artist's hand in building up the paint to the required density.

The new paintings may look very different from the earlier work, but in fundamental terms of attitude and approach nothing has changed. The collage principle is still at work in the intuitive juxtapositions of images from magazines and similar ready-made material. The imagery, even in those cases where it is easily identifiable, provides no more clue than before to the meaning of the picture in any literal or symbolic sense, since it is only one of a number of elements and devices used in the making of the painting. Technique continues to be a major preoccupation, with surprising mixtures of materials normally thought to be incompatible and with three-dimensional additions which extend the pictorial illusions into real space.

The new paintings provide eloquent proof of the lateral, rather than linear, thinking which lies at the root of Phillips's work. The outward form of the paintings has been drastically rephrased by a change in the nature of the imagery and in the tools and materials employed, but the content, if defined in terms of operating principles, remains basically unaltered.

'There's a series of many different overlapping preoccupations that keep emerging and disappearing, and then might re-emerge under some other disguise', concedes Phillips. 'In one sense I'm constantly reaffirming everything I've done, but at the same time constantly destroying, ending that and starting a new thing. But for me that's the only way it carries on being interesting.'[1]

This attitude of wilful contradiction is the source of a number of conflicts, both conscious and unconscious, within Phillips's work. From the beginning he has brought together elements generally considered to be mutually exclusive, not just in the way of technique but in terms of stylistic affiliation. The machine aesthetic merges with colour field painting, Pop crosses over into Conceptual Art as advertising imagery gives way to the artist's own market research, and geometric abstraction is injected with the intuitive juxtapositions of images characteristic of Surrealism. It is not a question of deliberately seeking to combine opposites, but rather of adapting to his own ends whatever he finds of interest.

Phillips has drawn from a great range of twentieth century art; Cubist and Dadaist collage and photo-montage, Surrealism, Léger and Purism, Kandinsky, Abstract Expressionism, Jasper Johns and Robert Rauschenberg have all left their mark. He has also studied pre-Renaissance painting and, more recently, has explored the techniques of Dutch still life painters such as

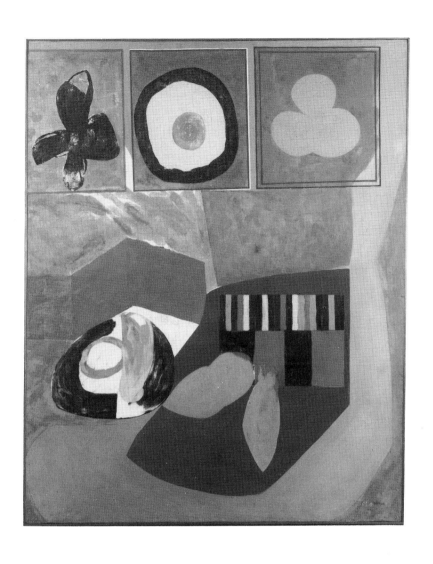

Bingo *1960*
oil on canvas 177.4 × 145.3
private collection *(cat. 1)*

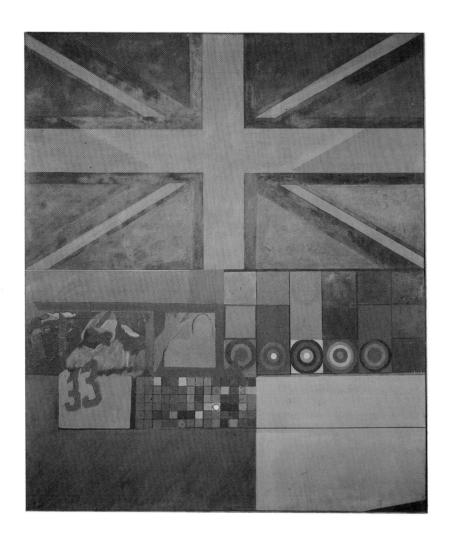

Purple Flag *1960*
oil and wax on canvas 213 × 184
private collection *(cat. 2)*

Jan Davidsz de Heem (1606–84). In Phillips's view, however, it would be an unnecessary conceit or intrusion to make direct reference to the work of other artists in his own paintings. Instead his preference is for ordinary images of the kind one comes across every day, painted with recourse to tools and materials – household gloss paint, car paint, photographs and the airbrush – familiar from outside of the realm of fine art. Often choosing deliberately vulgar imagery, Phillips nevertheless commands an extreme refinement of technique, even though his method of painting may have been adapted from an equally unrespectable source in commercial art.

Phillips maintains that anything can be material for a picture, yet he has demonstrated on many occasions a preference for a particular range of obsessive images. Magazines, books, and decals have provided a convenient range of images already processed into two dimensions, the result being that there has been a preponderance of advertising and mass media imagery: games, motorcycles, cars, machinery, pin-ups. To view the paintings purely as a materialistic revelling in consumer products, however, would be to ignore the emotional dimension provided by the juxtaposition of images, bold colours and geometric elements, just as seeing the images exclusively in terms of their two dimensions would be to miss the consistent involvement with illusions and with complex spatial systems.

There is no doubt that, until recently, Phillips's paintings have been aggressively direct, and that much of their impact has emanated from the positively-stated images, rendered as precisely as possible so as to provide an immediate point of recognition and contact with the viewer. In terms of meaning, however, the paintings are disconcertingly enigmatic and open-ended. Rather than direct the viewer's attention towards a thematic resolution, Phillips expects the viewer to take responsibility for making sense of it for himself.

'A person who looks at a painting should be able to create himself, he should have the freedom to interpret. This is why a painting for me must be complicated, with a lot of different references, handlings of paint, points of view and illusionistic changes. You can read it in a million ways. It just depends on how interested the particular person is. The mistake is to look at it in a particular way and say "That's that." It's not. I would prefer that it remain in that state of tension. I would prefer that there is a game which can constantly be played with the painting which is never resolved. You can't win, you can't lose. It's better that way, because then the painting is self-generative. Each individual can interpret it in his own way.'[1]

Phillips is not cultivating mystery for its own sake when he refuses to pin down the meaning of his paintings, nor is he taking the easy way out when he says that a variety of interpretations are possible but that no one reading is necessarily the 'correct' one. His urge to involve the viewer as a collaborator and active participant rules out the possibility of imposing specific meanings. These visual games are an invitation to share in the artist's emotional life and experience of the world, with an emphasis on the sharing. Since no manual activity is involved, the game is ready to be played at any time; all that is needed to set it into motion are one's own emotions and intellect.

Games are meant to be fun, and there certainly is a great deal of pleasure afforded by Phillips's work in terms of colour, form, surface and imagery. It soon becomes clear, however, that it is not all light-hearted and easy-going. Even the fun-fair, beneath its surface of glitter and excitement, has its monsters, its distorting mirrors, its confusion of noise and movement. There is a sense of unease, too, in Phillips's paintings – sometimes obliquely stated in images of sexual frustration or impending violence – reaching at times an almost hysterical pitch in the frenzied clutter of sharply-defined images against stridently-coloured backgrounds.

It might be objected that I have already overstepped the bounds of neutrality by reading particular emotional values into the paintings. The issue, however, is precisely that the paintings *cannot* be appreciated as coolly-calculated celebrations of popular culture or merely as pleasing or dynamic formal arrangements. Some measure of interpretation is essential on the part of every viewer in order to release the emotional and mental potential of each picture, but it does not matter whether one interpretation accords with another, for there is no single 'solution', and therefore no winner and no loser. Assaulted and numbed by the

constant flow of images every day of our lives, is it not cause enough for celebration that paintings can still spur us to feel and to think?

The sense of menace which infiltrates this celebration is, perhaps, only the other side of the same coin: a despair on the part of the artist that the people he wants to reach may not be interested in art in any case. One is enticed towards the paintings by various means: largeness of scale, brilliance of colour, familiarity of imagery, beauty of surface and virtuosity of technique. Having been seduced into looking at the painting, the problem of meaning is then thrown back to us, leading us, paradoxically, to a state of confusion within the context of a very assertive statement. Once more we are returned to the state of tension and to the contradictions which form the very substance of Phillips's work.

'There is no such thing as nonsense,' maintains Phillips, who regards painting as an unconscious activity. 'One "dreams" into a painting. Not in the sense of Dalí, but this inexplicable feeling that one has, and a sudden, spur of the moment decision, are very important. I really dislike a painting when it is logical. It loses its spontaneity, and this is the only way I can retain any spontaneity, when I have a very logical way of working.'

Conceiving of his paintings as visual equivalents for emotions, it is essential to Phillips that decisions be made impulsively but that they be executed very methodically. 'It's very related to Surrealist painting, the early beginnings of dissimilar elements together. This fascinates me. You put two things together, and it becomes something else. If you put them together right, it generates a totally new experience that can be very powerful.'

A perpetual need to surprise himself thus underlies the formulation of each painting as well as Phillips's development as a whole. 'It becomes boring when you know what you're doing. That's why, even though it's always the same, there are abrupt stylistic changes in my work.'[1]

Arbitrariness, in Phillips's view, is not to be mocked or feared, but accepted as an essential part of the creative process. In the discussion of the artist's development which follows, some of these intuitive leaps will be singled out for examination in the hope that they may provide a few clues as to the sort of intuitive responses expected in return from the sympathetic spectator.

Bingo 1960, painted by Phillips some months after his arrival at the Royal College of Art in the autumn of 1959, is one of his earliest surviving paintings and the first evidence of the direction his work was to take over the following decade. Basically heraldic in its imagery and apparently spontaneous in execution, it nevertheless represents a synthesis of the conflicting artistic interests and experiences which had preoccupied him since his early teenage years. The artist's initial technical training, his study of pre-Renaissance painting, and his encounter with Abstract Expressionism and with the work of Jasper Johns all play their part.

Born in 1939, Phillips entered art school at the age of thirteen, spending two years (1953-55) at the Moseley Road Secondary School of Art in Birmingham, a school of applied arts where he was taught a number of disciplines including painting and decorating, sign-writing, heraldry, silversmithing, graphic design, architectural illustration and technical draughtsmanship. Phillips acknowledges that these craft skills, learned at an impressionable age, have all left their mark, as has the general emphasis on technical discipline and on perception.

'I remember certain techniques that impressed me at the time, and certain ways of thinking, attitudes, who knows, they have some sort of subconscious effect on you later.'[2] Significant, too, was the fact that Art History was not even mentioned, and that at first Phillips had no specific intentions of becoming a painter. Romantic visions of the artist's rôle or great ambitions to remake the Old Masters thus were, and have remained, completely alien concepts to him. In their place was a more purely physical pleasure in the visual stimuli in the world around him, and a desire to be of his own time.

Only after his move to the Birmingham College of Arts and Crafts in 1955, in the second year of his Intermediate Course, did Phillips decide to become a painter. It was during this period that he exhibited his first paintings, Social Realist 'political paintings' with titles such as *The Dispute* and *Early Shift*.[3] 'Birmingham is a factory town, and in those days a very working class orientated area. I just used to go out and draw factories and strikers. I did quite a lot

11

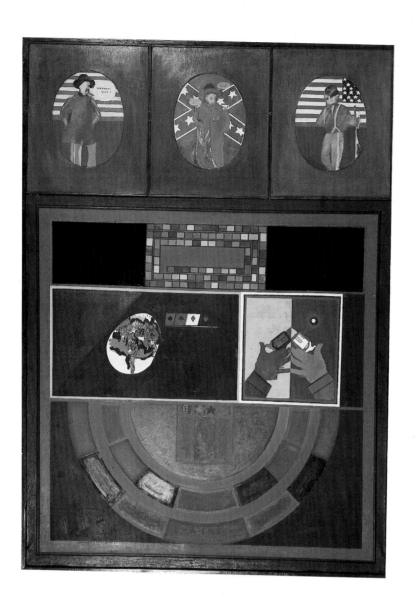

War/Game *1961*
oil and polished wood on canvas 210 × 150
Albright-Knox Art Gallery, Buffalo, New York
Gift of Seymour H. Knox, 1964 *(cat. 3)*

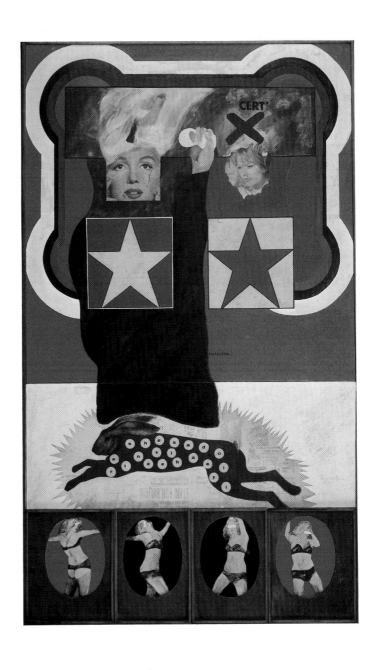

For Men Only - Starring MM and BB *1961*
oil and collage on canvas 274.5 × 152.5
Calouste Gulbenkian Foundation, Lisbon *(cat. 4)*

of those sort of street things with rather grey people, and painted the billboards and all that sort of thing.'[2] Phillips was soon to reject this particular form of figuration and especially the element of overt social comment, but the habit of taking his subjects from the immediate environment is one which has stayed with him.

While still at Birmingham, Phillips became interested in fourteenth and fifteenth century Italian painting, his curiosity whetted in part of the Pre-Raphaelite collection at the City Art Gallery. An opportunity to study at first hand the work of painters such as Cimabue, Giotto, Uccello and Bellini came with the travelling scholarship awarded to him by the College of Arts and Crafts on his departure in the summer of 1959. His journey took him first to Paris and then to Florence, Venice and other Italian cities; he bypassed Rome, presumably because its treasures of High Renaissance and Baroque painting held less fascination for him.

'I did particularly like early Italian painting, pre-Renaissance Sienese and Florentine painting, where they split up the surface of the painting. It wasn't an illusionistic space, it wasn't this hole in the wall. I was fascinated by the way they would divide up a panel. They would paint a figure and then they would have five or six little scenes going on, and to me that was very beautiful, and still is, as is much manuscript illustration. I like it very much, because it deals with another sort of space. As a rule I tend not to like the High Renaissance so much; the paint I like, but this illusionistic space as a totality never interested me so much.

'The early painters weren't interested in representing a scene, but as far as I can recollect, when an artist was painting the Virgin, that thing *was* the Virgin. These little extra things were stories that were symbolically complementing the Virgin or whatever it was. It was very interesting, because what they did *was* the object, whereas later on they were representing something. Even though it was very complex again in its metaphor, we don't particularly understand it, because unless you're a scholar we have no symbolic education any more. It possibly worked on other levels then, but for us it's just an illusionistic semi-narrative illustration, with its only interest in the various types of paint and compositional organization. But this type of unity didn't interest me enough.'[4]

Prior to his departure for Italy, Phillips had become acquainted for the first time with Abstract Expressionism at the Tate Gallery exhibition of *The New American Painting* held in February–March 1959.[5] It was a particular revelation for an artist who recalls asking as late as 1956, 'Do Americans actually paint?' He remembers being impressed most by Willem de Kooning and Clyfford Still, and to a lesser degree by Philip Guston and James Brooks, though Barnett Newman he found 'too radical.'[2]

Contact with Abstract Expressionism provided Phillips with the impetus to move onto a larger scale when he took up his place at the Royal College of Art in 1959. Among his fellow students, only Derek Boshier was working on a similar scale, although other artists revealed related interests: David Hockney at the time was working in an idiom inspired by Alan Davie, Allen Jones was studying the work of pioneers of abstraction such as Wassily Kandinsky and Robert Delaunay, and R. B. Kitaj - an American himself, and seven years older - was adapting de Kooning and Robert Rauschenberg to personal ends. On the whole the other students were painting still lifes and portraits in a rather traditional idiom, using a small scale and rather muddy colour.

Outside the Royal College, 'Abstract Expressionism was all the rage', as Phillips recalls. Abstract painters of a slightly older generation, such as Bernard Cohen, Robyn Denny and John Hoyland (then finishing his studies at the Royal Academy Schools), were responding in their own way to the boldness and large scale of American painting.[6] Phillips knew Hoyland slightly at the time but had little contact with the others; any formal similarities between Phillips's games-board paintings of 1960 onwards and the work of these hard-edge painters can be traced to common interests rather than to any direct influence from the older British painters. A more direct factor was the friendly spirit of competition between Phillips and the other young painters with whom he was sharing a flat at 58 Holland Road, Kensington, all of them students at the Royal Academy.

'At College you were learning "advanced figure painting" or whatever - just student exercises - and at

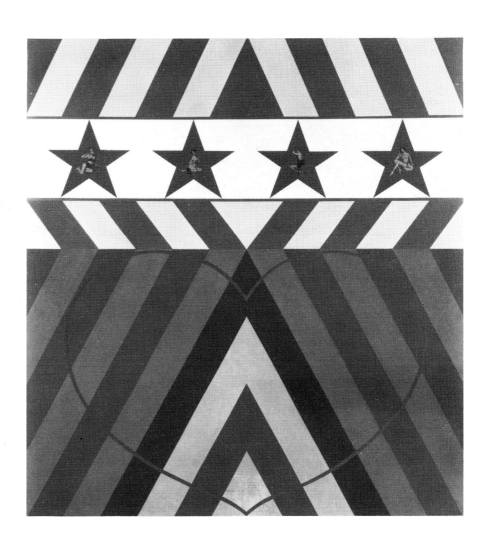

Forces Sweetheart/Synchronised *1962*
oil and collage on canvas 180 × 180
private collection *(not in exhibition)*

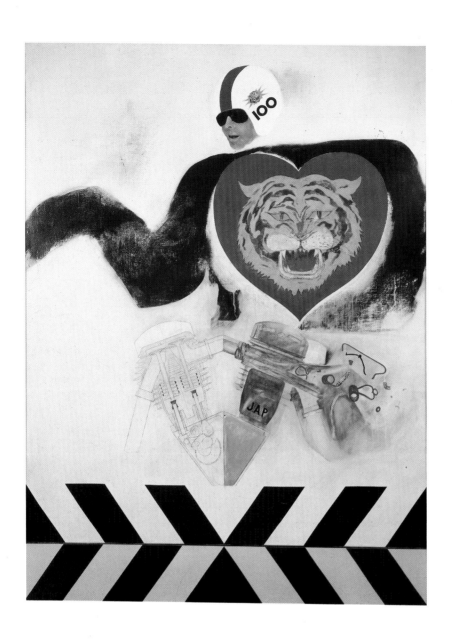

Motorpsycho/Tiger *1961/62*
oil on canvas with lacquered wood 205.5 × 150.5
private collection *(cat. 5)*

home one was trying to make one's own cultural contribution. The College was still geared to figure painting, but it was never explained why, or what one should get out of it. It was just a discipline that one had to do. So obviously one revolted against that when one was home and did exactly the opposite. I can't imagine that anyone knew what he was doing. I certainly didn't. One was just trying to make paintings that looked like other people's paintings. I remember Michael Upton always had sort of Rauschenbergs lying around, and he was trying to knock off Larry Rivers type paintings and doing it pretty well. David Willetts, who also lived in the flat, was doing Jackson Pollock type paintings. It was a whole mixture. The small room was full of these people, it was very exciting in a way, and everybody was trying to do their thing. De Kooning was the biggest influence at that time because he was at least more Europeanized than the other Americans, so you had perhaps a little more contact with it. Everybody was trying to imitate de Kooning. You had your book of de Kooning open and you were painting your pictures.'[1]

The only one of Phillips's paintings in this vein which survives, *Big Orange,* bears closer comparison with the work of other British artists such as Gillian Ayres than with the paintings of the Americans.[7] Thinly painted in orange and green, with much of the white canvas showing through, it consists of curvilinear forms suggestive of plant growth or flowers, loosely brushed with veils of colour.

Phillips's efforts to paint in this manner were shortlived. A turning-point, he recalls, was having one of his paintings, *Mad Tenderness,* laughed at by the art critic Lawrence Alloway during the setting up of the Young Contemporaries exhibition in March 1960. Phillips had met Alloway while still a student at Birmingham and respected his opinion, knowing of his position in the art world though unaware of his previous involvement with the Independent Group at the Institute of Contemporary Arts. Alloway's spontaneous reaction came as a salutary shock, and Phillips decided to rid his work of eclecticism and of characteristics that were foreign to his own natural abilities. 'I realized before that I wasn't an expressionistic type of artist in this gestural sense. So I did exactly the opposite and tried to do

that which I already had some familiarity with, and that was controlled painting.'[1]

Bingo 1960 marks Phillips's return to the principles of 'controlled' painting which he had learned in Birmingham, at the same time displaying a tentative move into the funfair imagery which he was soon to make his stock-in-trade. The colour remains muted, orange, red and yellow vying with black, brown and white; the artist's touch is still of central importance in the thin but sensuously-brushed surface; and there continue to be echoes of de Kooning's paintings of the 1940s in the ambiguous ovoid forms in the centre.[8]

What is new here is the heraldic simplicity of the imagery in the top row – a fleur-de-lys, a target, and a club or clover shape – and its compartmentalization within rigidly-defined areas. This method of encasing subsidiary images as a means of establishing a formal relationship with the central visual event is one of a series of personal responses to the characteristics of the early Italian altarpieces which Phillips had been studying. The tall vertical format itself can be related to this source, as can the organization around a central axis, with purposeful deviations from absolute symmetry. Different spatial systems co-exist, the suggestions of a shallow interior space in the central area counteracted by the flat and frontal boxed-in images above. Consistency of 'meaning' in a representational sense is disregarded – with enigmatic images placed arbitrarily against coloured backgrounds and a blandly-stated row of colour samples – since abrupt changes can be neutralized by the relative homogeneity of surface. Edges are sharply-defined, the outlines drawn in pencil and then filled in with paint.

'By this time I was interested in quite a lot of things from Max Ernst, Léger, and then to see the Americans, Johns and Rauschenberg, in some magazines. I had a girlfriend who went to New York, who lived there and who used to get a lot of stuff sent to me, and obviously I was incredibly impressed by Johns' and Rauschenberg's ways of working.'[2]

Johns' paintings had not yet been shown in Britain, and even in reproduction Phillips maintains that he was aware only of the targets.[9] Even this scanty evidence, however, provided vivid clues to a new

approach to picture-making. Most of the early criticism of Johns's work concentrated on his choice and use of subject matter, the way in which a target, for instance, acted as 'some simple visual symbol', satisfying in a matter-of-fact way Modernist demands for flatness and anti-illusionism and encouraging the basic act of looking.[10] Crucial, too, was the fact that the paintings not only represented ordinary objects but took the actual form of those objects, a neat solution to the dilemma of incorporating specific figurative references while preserving the status of the painted canvas independent of its representational function. Having already sensed a similar identification of subject with painted object in early Italian art, Phillips was quick to seize on the implications of Johns' work. 'I was interested in making a‾ painting that didn't necessarily refer directly to a subject. I was trying to make a picture that was self-contained. This was the thing at that time. One talked about making "objects" as opposed to "paintings", because painting at that time was still associated in a sense with a narration of some sort, particularly in the art schools.'[1]

Johnsian themes, implicit in *Bingo* in the choice of the target and in the sequential array of images in the upper register – a device used by the American in works such as the famous *Target with Plaster Casts* of 1955 – emerge in a more structured form in Phillips's *Purple Flag,* painted over the course of three months in the summer of 1960. Phillips recalls that he would not have chosen the Union Jack as an image if he had been aware of Johns's paintings of the American flag, readily admitting, however, that the subject occurred to him as an equivalent type of image to the target.

Rather than setting a single motif against a flat ground or simply presenting it on its own, as Johns had done, Phillips's flag, drained of its normal colour, occupies half the surface, with the other half filled with a range of smaller motifs: a row of targets, an American football player painted from a photograph, a grid of coloured squares containing an arbitrary sequence of numbers. These juxtapositions establish an alternative time scale, a sequence of actions within a static context, a suggestion emphasized by the presence of the figure with outstretched arm. As in Italian altar-pieces, in which predella panels establish a narrative complement to the starkly formalized central image, movement is introduced within a rigidly-controlled format. This device soon became a recurring feature of Phillips's work, for example in the invented comic-strip sequence of *Wall Machine* 1961 or in the striptease freeze-shots of *For Men Only – Starring MM and BB* 1961, in which each image is framed by a panel of polished wood.

'*Purple Flag* took me a long time to paint, constantly changing it and honestly probably not really knowing what I was doing. All I do know is that it was the first serious attempt at controlling the format of the painting, flattening out the surface and still leaving areas of illusion in. It was another way of painting and another use of imagery that, to my knowledge at that time, was not acceptable as a way of making paintings. From three months' concentrated work on this every evening, with a lot of little drawings and thinkings on the side, I probably learned more than from five years at an art school.'[1]

For the first time in Phillips's work, a number of contrasting techniques are incorporated within a single painting, each change of pace contained within a clearly-demarcated subdivision. The flag itself is painted in a mixture of oil paint with wax. Other areas are painted simply in oil, sometimes polished to change the appearance of the surface, at other times imprinted with newspaper as a means of speeding up the drying time and of creating a matt texture. Fragments of paper are allowed to remain on the surface, a device suggested by the work of Kitaj, whose sketchy notational style of the time was the source also for the treatment of the figure. The cancellation mark over the figure, a random decision which was quickly to become an obsessive image in Phillips's work, provides yet another deliberate break in the logic. 'I was trying to prove to myself that, within my capabilities, there are many different ways of approaching something which, when it's within a relatively rigid and controlled format, could work together.'[1]

One Five Times/Sharp Shooter 1960, painted immediately after *Purple Flag,* carries further not only the amusement arcade imagery but also the principles of conscious disruption and of intuitive juxtapositions

One Five Times/Sharp Shooter *1960*

of images from unrelated sources: a row of targets with actual holes punched in them, a grid of selected numbers, a diagrammatic representation of a sleeve pistol, and what appears to be a hare, half-obscured by a cancellation mark, muttering the curious phrase, 'JUST THE THING FOR TAXIDERMISTS AND BATMEN'. By this stage Phillips had begun to seek out additional visual information to use in his paintings. Diagrams he found particularly appealing; what they represented was more or less incidental, since their interest lay in the fact that they were found images of inexplicable fascination in themselves. The precision of draughtsmanship required in mechanical or scientific diagrams, placed at the service of objects which are often obscure to the uninitiated, serves to strengthen their enigmatic status. Phillips welcomes this ambivalence between familiarity and impenetrability not just as a means of keeping the paintings alive, but as an equivalent for the way one goes about one's daily business, sometimes feeling in control, at other times failing to comprehend the significance of objects and events with which one is confronted.

'There are certain periods where paintings tie up more than at others, but I don't think it is very important if a painting does tie up with a theme. This one obviously is to do more with a funfair and shooting, but it's peculiar enough to obscure it a little bit, enough to make it interesting. If it was just a comment on rifle ranges or something, it would be rather dull. One just had a peculiar feeling and tried to get this into the painting, using imagery that responded to that feeling. Certain types of fairground activity somehow came in with this type of feeling, rather like Orson Welles would often use a hall of mirrors or something in his movies. It's a place of fun, but somehow it has an undercurrent of menace the whole time. People did respond to this. The early paintings are not always what they seem to be; this undercurrent is always there.'[1]

Phillips's early paintings were worked out entirely on the canvas; it was not until late in 1963 that he began to make preparatory drawings. Taking as his starting point a strong formal structure, Phillips would then seek to 'fill this structure with the correct feeling and image and balance', an intuitive process made all the more difficult by his insistence that the result appear as assertive and confident as possible. This 'juggling of dissimilar elements until it feels right' could be an arduous process, but the effort was not to be visible.[1] The unpretentious imagery afforded by games, pinball machines, jukeboxes and the like was a convenient means of establishing the desired neutrality, though the process of building up the painting, as the artist revealed in a catalogue statement published in 1962, was every bit as subjective as that of the Abstract Expressionists: 'Some pictorial organization is essential, though the result is never preconceived but develops during the painting process. Content is important, as is the complexity of image and idea, relationships, format and sources. Each painting in its break-down and build-up becomes a personal experience. I like the finished object to exist, first and foremost as a FACT, as well as an identification of myself in an environment, and as a contribution to that environment.'[11]

The conflicting demands of deliberation and spontaneity occasioned a great amount of reworking in Phillip's early paintings, and accounts for the fact that in 1961 he completed only five pictures, each one, however, a surprisingly authoritative statement for an artist aged twenty-two and still a student: *Wall Machine, Entertainment Machine, Burlesque/Baby Throw, War/Game* and *For Men Only - Starring MM and BB*. Varied as they may be in terms of imagery - incorporating, as they do, monsters, cartoon characters, movie stars, pin-ups and soldiers from the American Civil War - they are united through their common reference to games, both in terms of structure and in the way that they engage the spectator's attention.

The central structure of *Wall Machine,* for instance, is provided by the solitaire game, into which the artist has inserted tiny images of monsters upside down. The formal simplicity of the game format supplied a heraldic image which gave Phillips the freedom to do whatever he wanted within it, just as the regular sequence of frames below allowed him the luxury of creating his own comic strip fantasy.

'I was very interested then in what I called "game formats." A game is also that type of thing, a big image subdivided into little pictures, and you would play this, so that the thing became a sort of visual game where

Wall Machine *1961*

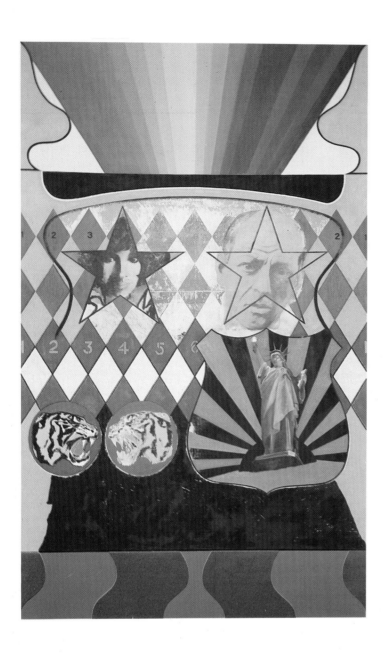

Forever Corporation *1962*
oil on canvas 244 × 152
private collection *(cat. 6)*

Spotlight *1962/63*
oil on canvas with lacquered wood 238 × 157
Bruno Bischofberger Gallery, Zürich *(cat. 7)*

more or less anything could be acceptable. Again this was from a highly emotional point of view. I had a lot of comic strips, but I wasn't selfconscious that this was anything particularly important. To me nobody had done it, so I thought I'd just stick it in, paint a comic strip. At the time there was nothing for me to go on. There was certainly no Roy Lichtenstein around that I knew of, or anybody else who was doing that. I never really continued it, it was just something that I did; it was a throwaway.'[1]

Comic strip images feature again in *War/Game*, though copied in this instance from American magazines. As Phillips himself admits, this is one of the few paintings he has done which is in context with a particular theme, that of the American Civil War, the centenary of which was being observed at that time. 'It seemed very strange to me at the time that somebody could actually celebrate a war, particularly a very brutal war where brother was shooting brother.' The flippancy with which the subject was being treated by the Americans struck him as rather sinister; in recognition of this he incorporated sick jokes into the speech bubbles emanating from the figures.

If *War/Game* stands alone in its satirical intentions, it nevertheless relates closely to Phillip's other paintings of the time in terms of imagery and of format. The gun as a sign of irrational violence and power, already used in *One Five Times/ Sharp Shooter*, reappears in the assemblage of diagrams in the lowerright of *Entertainment Machine*; although the contraption in the latter incorporates a pistol and a diagram of bullet sizes, the image as a totality is invented and, it goes without saying, inoperable. The artist remains neutral about the question of violence. Moralistic sincerity does not enter into it. When Goya painted *The Shootings of May 3rd 1808* - a painting chosen by Phillips as the subject of the transcription required by the College - was he simply making a straightforward political statement, or was he not also using the drama of that violence to his own pictorial ends?[1][2]

An ever wider range of techniques is incorporated into Phillips's work during this period. In *War/Game*, for instance, black gloss household paint - first used in *Wall Machine* - is smoothed down with a pumice stone and played against areas of matt

paint, waxed paint, and polished paint. The uppermost row of images is painted on separate canvases, onto which have been glued panels of polished wood. All these diverse elements, pieced together in a craftsmanlike way - one befitting the son of a carpenter - are housed, finally, within a deep box frame. The actual process of construction thus becomes another means of composing a picture, another system to be added to the ever-growing range of possibilities.

Similar constructive devices are used in *For Men Only - Starring MM and BB*, notably in the lower row of images encased in wooden frames. The idea for this, Phillips readily admits, relates to the predellas of the pre-Renaissance altarpieces he so admired, 'but it also comes from specific feeling: something Victorian, ancient, used, and menacing at the same time, but then with imagery that was up-to-date and underground. How conscious that was I don't remember.'[1] By this time, however, it is clear that Phillips had developed sufficient self-confidence to adapt formal characteristics of the art of Cimabue and Giotto to a contemporary context, using the imagery, materials, blaring colours and frantic emotions of his own time. Among the elements which he has drawn from the pre-Renaissance are the tall vertical format organized around a central axis, the underlying symmetry subtly broken into; the use of reversals and interplay of positive with negative forms; the notion of serialized narrative, expressed in the form of stark repeats; a preference for an insistent frontality and for a compartmentalization of images; and an emphasis on the physical presence of the picture by means of its actual construction. These are all devices to which Phillips was to continue to refer directly at least as late as *Gravy for the Navy* and *Four Stars* of 1963, in both of which symmetrical images of seductive women framed by star shapes are presented like the haloed attendant angels to an early Madonna.

The imagery of *For Men Only* is drawn from a number of separate sources. The starting point was the bold games-board shape in the upper half, invented by Phillips as a suitably formal container. The collaged heads of Marilyn Monroe and Brigitte Bardot, the two great pinups of the time, were magazine photographs that he happened to

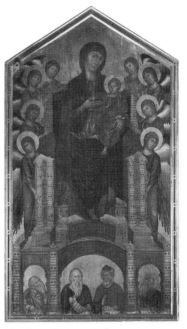

Cimabue: **Madonna Enthroned with Angels and Four Prophets** *c.1280/85*

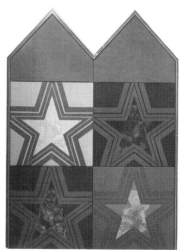

Four Stars *1963*

22

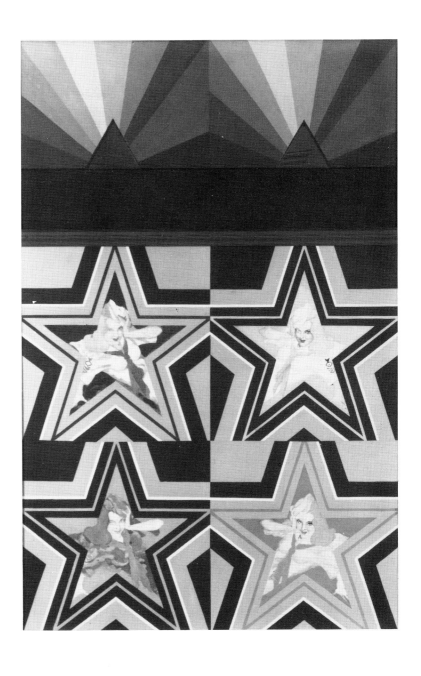

Gravy for the Navy *1963*
oil on canvas with lacquered wood and glass 233.5 × 157.5
Oldham Art Gallery and Museum *(cat. 8)*

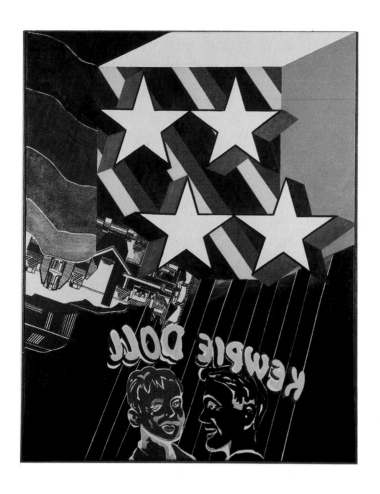

Kewpie Doll *1963/64*
oil on canvas 132 × 107
private collection *(cat. 9)*

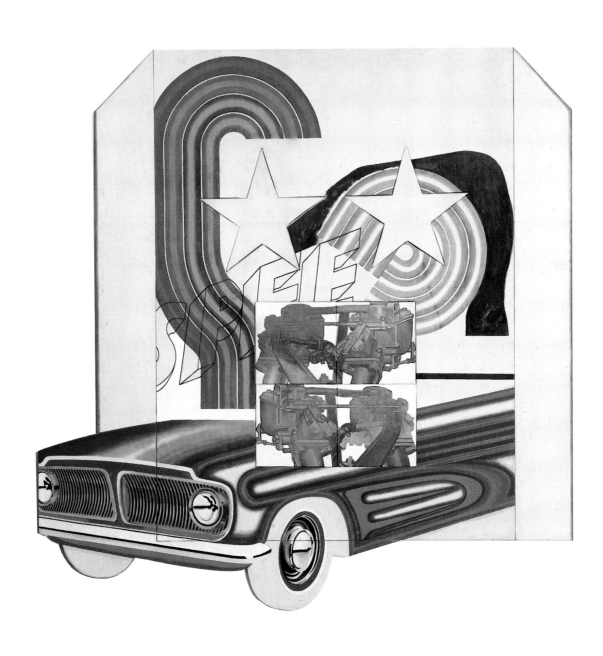

AutoKUSTOMotive *1964*
oil and kandy kolor on canvas with inset panels 275 × 275
private collection *(not in exhibition)*

have 'lying around,' rather than images which he had consciously sought out. The stars, chosen here as another standard motif equivalent to the flag or target, have in this initial instance a punning function, although they soon became a favoured personal element that was used in a variety of ways.[13] The image of the hare was partly invented and partly suggested by a Victorian game - a subject about which Phillips had informed himself through books - of 'The Tortoise and the Hare.' The apparently random letters contained in the circles within the hare form the message 'She's a doll' followed by the name of the stripper, painted from photographs, represented in the sequence of images below. The newspaper image imprinted in the yellow image around the hare, taken from the pop music paper *Melody Maker* and bearing the clear headline 'ELVIS FOR BRITAIN' was selected, Phillips maintains, not for its particular message but merely because it was a journal which he used to read regularly and which reflected his interests.

It would be possible to construct various contradictory explanations of the narrative implied by the juxtapositions of images in the painting. So many actions and written messages are incorporated into the picture that one feels impelled to make sense of it in thematic terms. It must be repeated, however, that there is no single resolution, no magic key to unlocking its meaning. In order to experience the painting fully, each spectator must work out a logic that satisfies him or herself.

The figure with outstretched arm in *For Men Only* - a not so distant relation of the similarly-engaged football player in *Purple Flag* - functions as a sort of stand-in for the spectator, encouraging one to approach the painting and to take part in its games. Just as the artist has had to make a series of decisions in producing the picture, so one is offered constant choice. There are different surfaces and different ways of applying paint. There are a number of ways of creating images: they can be taken ready-made in the form of collage, invented, transcribed from photographs or diagrams, or transferred as direct imprints into the paint from newspapers. There are different ways, too, of getting words onto the surface, such as newspaper collage, newspaper imprints and Letraset; in *Wall Machine*, by contrast, the words are written by hand. The possibilities are endless, limited only by the artist's sensibility and intuition.

Each of Phillips's paintings at this time operates according to its own set of rules. *Burlesque/Baby Throw* incorporates pin-up photographs collaged onto the surface and varnished, along with four wooden rings which, in theory, can be thrown at the canvas. Not without irony, Phillips here takes to its literal conclusion the notion of spectator participation implicit in Johns's targets and the combination of real objects with painted surface in Rauschenberg's 'combines'. *Entertainment Machine*, by contrast, is wilfully obscure in its function, combining as it does a strange mechanical apparatus, a piano keyboard, a cancellation mark and the head of the Amazing Colossal Man. A collaged panel in the upper-right, bearing the words 'Modern Schools,' appears to take the form of an Abstract Expressionist painting by Clifford Still, although Phillips denies that he was consciously making an impudent gesture towards 'modern schools' of painting.

Phillips maintains that the very disparateness of the imagery he was using was a motivating force in his decision to work on a large scale. 'I could never work on a small scale, I never felt satisfied. I need room to move around in, and to get the compositional elements to relate I've got to have a certain amount of space in between.'[1]

The assertiveness of Phillips's paintings from 1961 onwards can perhaps be accounted for also by the recognition he was already beginning to receive, as well as by his situation at the Royal College. Phillips was president of the organizing committee of the 'Young Contemporaries' exhibition held in February 1961, with Allen Jones, recently expelled from the College for his excessive independence, as secretary.[14] On the advice of Lawrence Alloway, their paintings and those of Royal College colleagues such as Kitaj, Hockney, Boshier and Caulfield were rehung as a group shortly before the opening of the exhibition so as to make a greater impact.[15] The attention they received in the press confirmed their sense of group identity, particularly as they were under great pressure from the College staff to conform to a more traditional way of working.

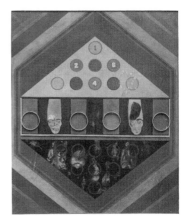

Burlesque/Baby Throw *1961*

When Allen Jones was expelled at the end of his first year in the summer of 1960, Phillips was given a provisional pass and told to reform or else leave at the end of three months. As a matter of expediency, he painted 'total English mannerist art school' nudes and still lifes in grey. These pleased the staff and he was allowed to stay. At this point he brought in the paintings reflecting his real interests, which he had been working on simultaneously at home.

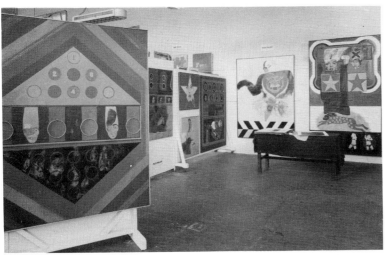

Installation view of paintings by Peter Phillips, Royal College of Art diploma show, spring 1962

This caused, of course, serious friction with the staff and led to Phillips's decision to transfer in his third year to the Television School, while continuing to devote most of his time to painting.[16] The isolation from the staff in the end proved salutary in establishing an independent way of working, particularly as the students themselves provided their own standards and mutual support. 'I think the basic level of competition is quite important in a very small area between people,' Phillips later recalled. 'Fighting a system, and knowing that you weren't alone, strengthened us.'[2]

The discovery that older artists were working along similar lines was a further source of encouragement. Peter Blake, whom he knew well by the end of 1961, if not earlier, came closest to his way of thinking.[17] Richard Hamilton he recalls meeting in about 1962, but Hamilton was based in Newcastle then and his paintings were not really seen until the time of his first one-man show in 1964. Phillips knew nothing, moreover, of the exhibition called *This is Tomorrow* in which Hamilton took part in 1956, as he was aged only seventeen at the time and was living in Birmingham.[18] Hamilton's involvement with the specifics of contemporary iconography, moreover, is at variance with the more intuitive approach favoured by Phillips. A closer spirit is the Scottish sculptor and printmaker Eduardo Paolozzi, who in Phillips's own words is a 'collage assemblist' like himself. Phillips did not meet Paolozzi, however, until 1964, and Paolozzi's *Bunk* collages of the late 1940s, often cited as early works of Pop, were not in fact publicly exhibited until they were acquired by the Tate Gallery in 1971. It would be wrong, likewise, to consider the discussions of the Independent Group in the mid-1950s as a spur to Phillips, since he knew nothing of their activities.[19] Questions of precedence are beside the point. The real issue is that a number of artists both in Britain and America were affected by a similar change in sensibility and had available to them essentially the same range of material.

Phillips readily accepts the Pop label, if it is taken in terms of attitude, style and technique as well as of image. In a three-way interview with Allen Jones and Richard Smith published in 1965, Phillips agreed that he was probably 'more orthodox' than the others in his use of Pop imagery. 'I consciously make a selection from ordinary things which I like and then use them as a contemporary iconography. But still,' he was quick to explain, 'my aim is not to make comments or develop a story about the objects I use. I try to transform them in order to make a painting and I use them simply as images.'[20]

In Phillips's own estimation his greatest mentor was not a contemporary artist but an earlier twentieth century painter, Fernand Léger. His interest in Léger began, he recalls, while he was still at Birmingham mainly through reproductions in books, and one of the first art books he purchased was the monograph on the artist by Robert L. Delevoy published in 1962.[21] In his essays on 'The Machine Aesthetic,' which Phillips did not read until some years later, Léger praised the beauty of machine-made objects, a beauty which he stressed was independent of what they represented. Feeling, not intellect, he insisted, was the realm of painting.[22]

The pointers provided by Léger's work were particularly useful to Phillips because of their flexibility. Foremost among these is the 'law of

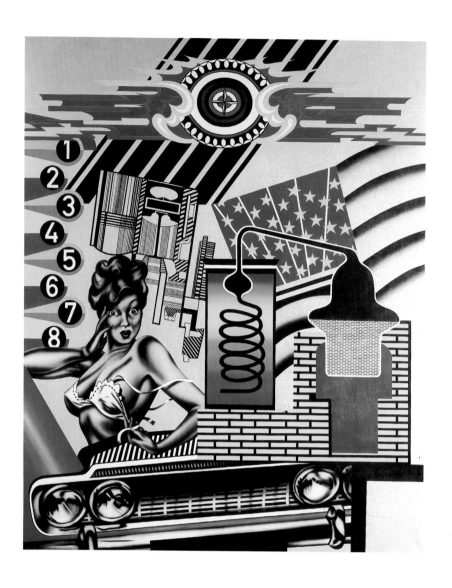

Custom Painting No. 2 *1964/65* (copy *1972*)
oil on canvas 214 × 175
private collection *(cat. 10)*

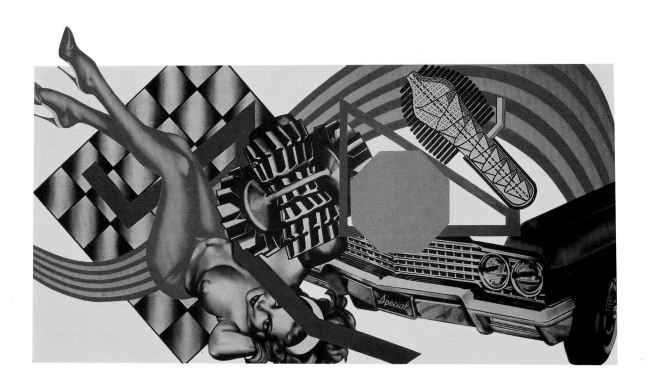

Custom Painting No. 5 *1965*
oil on canvas 175 × 300
Bruno Bischofberger Gallery, Zürich *(cat. 11)*

contrasts' - between, for example, real and painted elements, fragments and wholes, flat and volumetric images, and unrelated objects suspended in an arbitrary space - which Léger considered 'the eternal means of producing the impression of activity, of life.' Associating himself with technology, Léger sought to create 'beautiful objects' with the aid of 'mechanical elements,' rejecting in the process what he considered to be the overly obvious individualism of the autographic mark.[23]

'Léger did exactly what I do. He goes into the street and sees a photograph of the *Mona Lisa* and thinks, "That's exactly what I want with a bunch of keys." That's a totally pure gut reaction. This is where I feel a certain affinity. He would go to the industrial fairs and find the things beautiful, and I agree totally with him. But I'm not obsessed with technology in the way that he was, because I don't share his dream of industrialization. In fact totally the contrary, but they still fascinate me as elements for a painting.'[1]

Phillips's interest in Léger led him in turn to the work of Americans such as Stuart Davis, Charles Demuth and Charles Scheeler, and linked up also with the work of the Dadaists Kurt Schwitters, whose collages consisted of humble found objects, and Francis Picabia, whose diagrammatic portraits of machines find echoes in works by Phillips such as *Motorpsycho/Tiger* 1961/62.[24] Equally important to Phillips as a source of ideas was Laszlo Moholy-Nagy's pioneering book *Vision in Motion*, originally published in 1947, which made a strong case for the harnessing of technology to art as a means of expressing feelings in a manner appropriate to our age.[25]

Technology initially entered Phillips's work in the form of imagery, and it was only at a later stage that he became interested in employing machines as working tools. The double motorcycle engine in *Motorpsycho/Tiger*, for instance, was drawn by hand from a diagram in a magazine. The engine's role, in a sense, is as a substitute for the figure. While the cyclist is represented as a helmeted head with little trace of personality, the anatomy of the machine is lovingly detailed, treated on one side as a kind of skeleton drawing and on the other as its exterior of metallic skin.

The sense of depersonalization in a highly industrialized society, hinted

at in the subconscious selection and placement of imagery, is implicit also in the direct use of ready-made material in this and other paintings of 1962. The tiger head on the helmet is a self-adhesive decal purchased at a motorcycle shop; the larger tiger head enclosed in the green heart is a hand-painted facsimile of the same image. Similar exchanges occur in other paintings. *Tribal 1 × 4* 1962 incorporates four decals of a speeding motorcycle and a schematically-painted representation of an Indian head. While this head is an enlargement of a decal which had been used in *Motorpsycho/Ace* 1962, the motorcycle has a later life in *MULTImotorPLICATION* 1963, where it is used both as a painted repeat and as a wooden element in relief. Similarly, the decal which supplied the model for the leaping tiger in *Motorpsycho/Club Tiger* 1962 is stuck on the middle of the painted image itself.

Since decals are an easily-accessible source of visual material, their use in the paintings in one respect is merely a matter of convenience, an economical way of producing an image. They exist as two-dimensional facts, and consequently can be taken exactly as they are or merely enlarged to the required size. Phillips makes a particular point of not changing the image so as not to 'add' himself to it, jealously maintaining a neutral stance. On the other hand, they are not chosen completely arbitrarily. Their boldness of design was attractive to Phillips at the time, as was the fact that they were meant to be stuck on motorcycles, cars and leather jackets, reflecting his attitude to the environment in which he lived. 'I was more into the physical activities of the city, the seedy side, than the refined side. It had a certain dynamic that I felt at home with.' The irony, however, of using something so anonymous as a personal sign was not lost to him. 'It's an individualization of that machine object that somebody purchases, and then individualizes with non-remarkable images that are already manufactured in mass-production for individualization. So you have this contradiction in terms.'[1]

Decals were only one of several devices that Phillips used for producing strong images without recourse to conventional forms of drawing. In *Philip Morris* 1962, for instance, three identical advertisements printed on card, which the

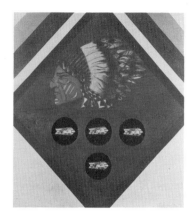

Tribal 1 x 4 *1962*

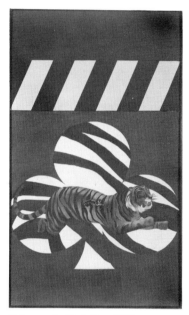

Motorpsycho/Club Tiger *1962*

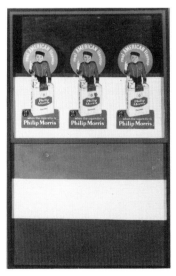

Philip Morris *1962*

30

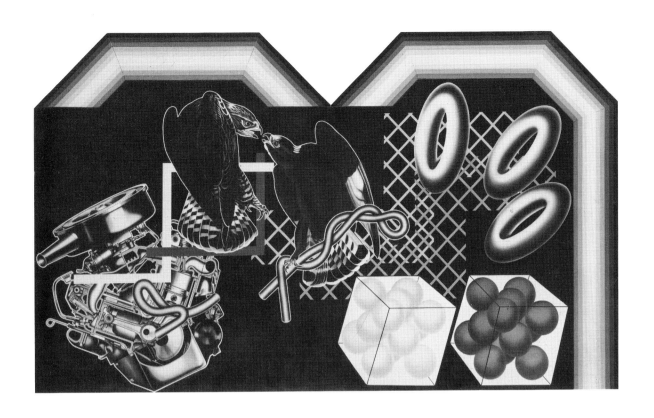

The Random Illusion No. 1 *1968*
acrylic on canvas with coloured plexiglass 200 × 340
Hans Looser *(cat. 12)*

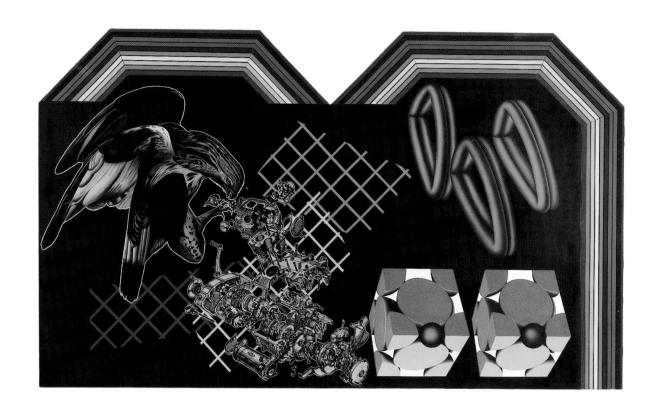

The Random Illusion No. 3 *1968*
acrylic and tempera on canvas with lacquered wood 200 × 340
Galerie Neuendorf, Hamburg *(cat. 14)*

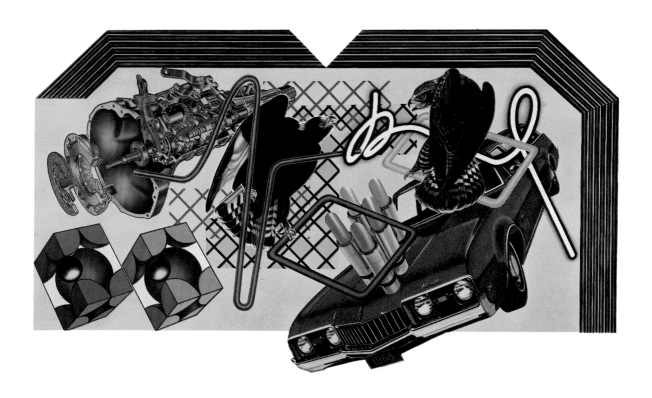

The Random Illusion No. 6 *1968*
acrylic and tempera on canvas with lacquered wood 228 × 401
Galerie Neuendorf, Hamburg (cat. 15)

artist had discovered in the gutter outside his local tobacconist, supply the entire image content. The structure for the image is provided in an equally direct way by means of a recessed canvas at the top, a strip of hardboard to support the advertisements, and a separate canvas divided into three equal stripes of flat colour. Two tiny canvases of the same year, *Racer* and *We Three Ships*, propose an equally anonymous method for creating images: in each case a single image is repeated three times with the aid of a commercially-available stencil intended for the use of children. Neither of these methods was pursued any further by Phillips: the stencils seemed too easy a solution, while the methods underlying *Philip Morris* seem to have struck him as too similar to those employed by Peter Blake.[26]

Pin-up imagery, which had first appeared in the form of collage in paintings such as *For Men Only* and *Burlesque/Baby Throw*, re-entered the paintings in 1962 as ready-made self-adhesive images. In *Forces Sweetheart* seductive poses are struck by four women - each one the product of the Italian illustrator Moska - stuck onto star shapes painted with blue gloss and then varnished over. The bold chevron design, overlaid with the outline of a heart painted with the same shiny blue, captures with great directness the razzle-dazzle and barely suppressed excitement of big cities at night, the contrast of reflective with matt surfaces providing a convincing equivalent to the disorientating effect of neon lights. In *Distributor* similar pin-ups are stuck onto a series of panels which can be rearranged by the spectator at will, allowing a constantly renewable permutation of images. Once more we are invited to take part in an imaginary game, but one involving high emotional stakes: winning bears the promise of a seductress reclining in anticipation, while losing is signified by the presence of a coldly aloof seated figure. The international road sign placed along the central axis provides a vivid warning of the 'other dangers' which lie in wait for all those involved in games of sexual fantasy and seduction.

Once he had used these stick-on images, Phillips soon began to seek out other girlie images of the 1940s in magazines, transcribing them onto paintings such as *Four Stars* and *Gravy for the Navy*, both dating from 1963. The title as well as the image of the latter was taken from a drawing by Vargas published in *Esquire*. Phillips recalls that he liked such images not because they were from the '40s but because they corresponded in feeling to the other elements he had been using, neither real nor unreal.

'They complemented each other. Therefore a diagrammatic image of a motorcar was the same as this rather diagrammatic shorthand of a woman. They were both beautiful in one sense, and in another sense not so beautiful. There is always a certain duality, but again my emotional reaction was positive, and I was able to make aesthetic judgments within this particular subculture of imagery. It's quite amazing that even with the most awful of material one can say "This is a good decal and this is a lousy decal," and "This is a good pin-up and this is a rotten pin-up," or "This is a beautiful machine." One is already making decisions in an aesthetic way even in the choice.'[1]

It is often assumed that Phillips was devoted primarily to Americana, but it should be evident by now that this was not the case. 'I've never been analytical about American things. I like American things, but I also like Japanese things, I like French things, I like Swiss things. American cars possibly I liked more, simply because of their greater baroqueness; they just had more interesting things to paint in them than stylized Italian cars.' Even the presentation of goods from a consumer's point of view, as Phillips points out, was not particularly an American phenomenon. 'The Industrial Revolution happened in Britain, as well as advertising. The Americans maybe took it a bit further, but there's not much intrinsic difference. It's been here since Victorian times, even though it has never pushed its nose out as aggressively.'[2]

Forever Corporation is one of the few paintings that comments explicitly on American culture, but one would be hard-pressed to interpret it as a mindless celebration of American values. The juxtaposition of one of the stars of the New York art world, Jackson Pollock - who, incidentally, had died six years earlier - with the Statue of Liberty on a heraldic shield, a numbered grid, two tiger heads painted from decals, and an anonymous beauty from a German magazine, reduces the famous painter to the status of just

Racer *1962*

Distributor *1962*

34

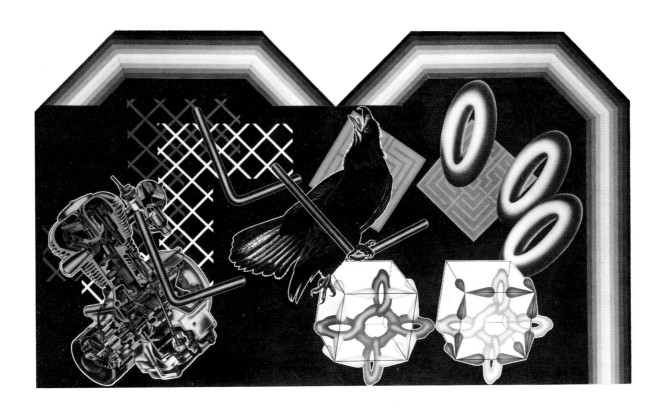

The Random Illusion No. 2 *1968*
acrylic and tempera on canvas with coloured plexiglass 200 × 340
Waddington Galleries, London *(cat. 13)*

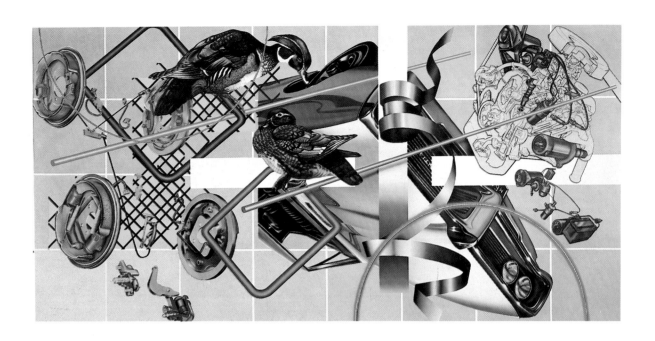

Select-O-Mat Techtotempest *1971*
acrylic on canvas 250 × 510
Galerie Neuendorf, Hamburg *(cat. 16)*

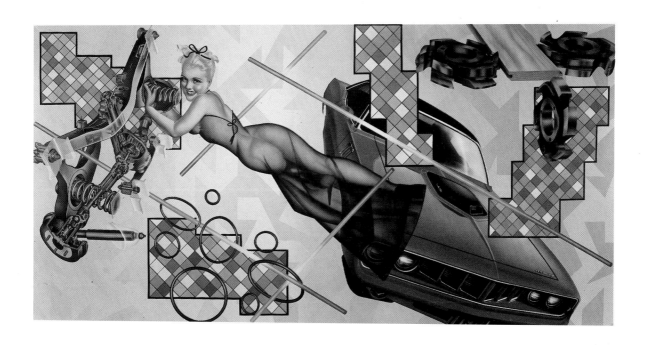

Art-O-Matic Cudacutie *1972*
acrylic on canvas 200 × 400
Waddington Galleries, London *(cat. 17)*

another motif, no more and no less important than any other. The title of the painting, borrowed from a science fiction novel, carries its own irony. Without stretching the point too far, it should be noted that Pollock's head was painted from a poster of a New York gallery exhibition, the features transferred with the aid of a tracing and then painted in tones of grey - the symbol of free painting transformed into a replica of a photograph.

The very wilfulness of the unrelated elements and fragments in paintings such as *Forever Corporation* and *Kewpie Doll* 1963/64 has its logic, for it provides an equivalent to the arbitrary manner in which one receives sensations in the course of a normal day. Bombarded by dissimilar visual experiences which make a uniform focus impossible, one is forced to make a selection, taking in some things and not others according to one's own priorities. 'Every day things *are* arbitrary,' Phillips agrees, 'and my sensations *are* arbitrary. I look at a telephone kiosk and a car passing, a girl over there and a window up there. . . There *is* a logic, but it's a logic that I don't want to define.'[1]

Illusionism and factuality are closely related in Phillips's paintings. One is constantly forced to re-examine the evidence to confirm whether what one thinks one sees is actually there. First glances, as one knows through experience, are often misleading. In order to encourage us to look closer, Phillips sometimes cuts into the surface, as in *SUPinsetER* and *INsuperSET*, both dating from 1963, in which the star shapes and central panels alike take the form of inset canvases. By contrast, the triangles through which the wall can be glimpsed in *Spotlight* 1962/3 are not cut into the canvas, but are the result of the piecing together of separately-coloured wooden strips. The imaginary identification of the triangles as prisms, through which light is refracted into the colours of the spectrum, is taken further in *Gravy for the Navy* by the insertion of pieces of clear glass. On occasion motifs which appear to be cut out, like the stars in *Kewpie Doll*, in fact form part of an unbroken surface, just as images which appear to be painted are sometimes stuck on and *vice versa*. In *MULTImotorPLICATION* the uppermost motorcycle is in relief, literally advancing from the picture plane as a means of matching the image of forward movement.

AutoKUSTOMotive 1964, at 2.75 × 2.75 metres the largest canvas Phillips had yet painted, restates a number of favoured devices and concerns while introducing elements that were to be elaborated by the artist over the following decade. As before, there are inset panels: the star-shaped canvases are primed but unpainted, while the inset images of carburetors are drawn in first with line and tone and then sprayed with colour from cans, the white surrounding area painted in last. As in previous works such as *Motorpsycho/Tiger,* separate panels are appended to the main canvas, though this is now taken a stage further so that the overall shape of the canvas takes on the form of the image represented. The twin subjects of machinery and of vehicles in motion – both already dealt with by Phillips and with a history stretching back at least as far as the Futurists – are represented here in a particularly aggressive form.[27] This work marks, too, the first overt treatment of the theme of customizing, implicit already in the use of decals in earlier paintings such as the *Motorpsycho* series. Largeness of scale, too, is brought to a logical conclusion. 'I remember saying that I wanted to paint a car as big as a car and a house as big as a house. I was fascinated with this idea, but I never really took it much further. It seemed to work on that scale.'[1]

The shaped canvas was an increasingly popular device among figurative and abstract painters alike in both Britain and America; among the artists who had availed themselves of it were Hockney, Boshier, Jones, Richard Smith, Frank Stella and Ellsworth Kelly. Although he returned to a shaped enclosure in the *Random Illusion* series and other paintings of 1968, Phillips did not pursue the notion for the time being and had no urge to bring the shape out into the third dimension. He recalls that the decision to take the idea no further was occasioned in part by the fact that Richard Smith had already done so in works such as *Piano* and *Gift Wrap,*[28] but adds that 'I was probably more concerned with other things - with the image and the definition of the image.'[1]

Phillips had early made a conscious decision to use images exactly as he found them, reasoning that whatever it was that had stimulated his imagination could

MULTImotorPLICATION *1963*

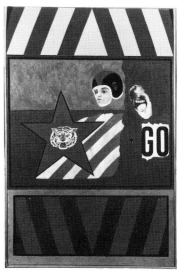

Motorpsycho/Go *1962*

38

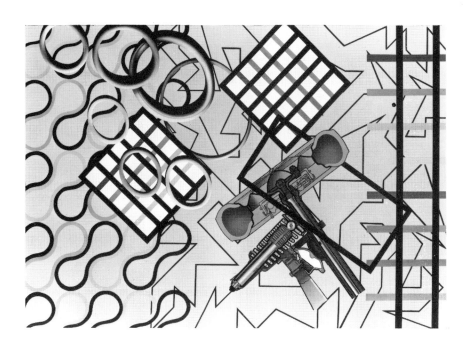

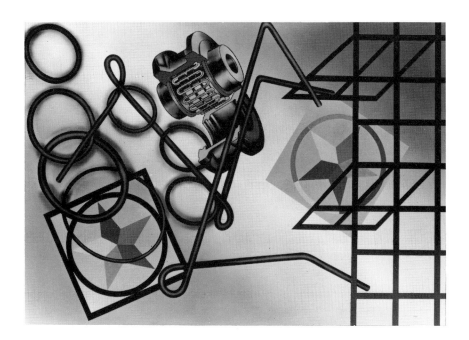

TOP
Composition No. 5 *1972*
acrylic on canvas 93 × 133.5
Galerie Neuendorf, Hamburg *(cat. 19)*

BOTTOM
Composition No. 14 *1972*
acrylic on canvas 93 × 133.5
Galerie Neuendorf, Hamburg *(cat. 21)*

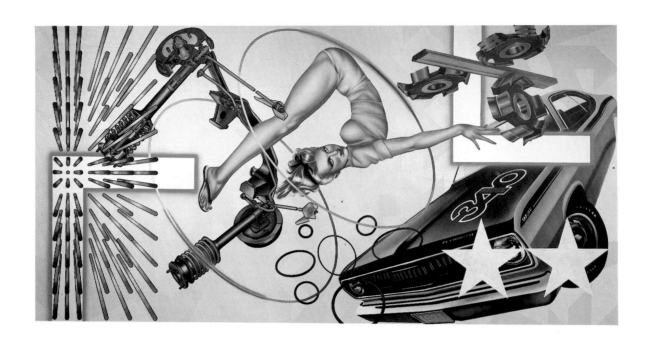

Art-O-Matic Loop di Loop *1972*
acrylic on canvas 200 × 400
Galerie Neuendorf, Hamburg *(cat. 18)*

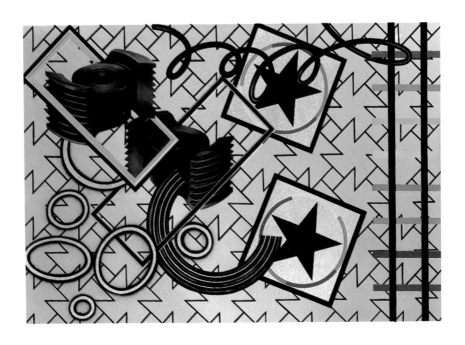

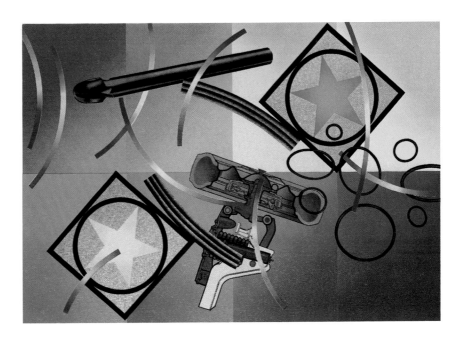

<div align="center">

TOP

Composition No. 8 *1972*
acrylic on canvas 93 × 133.5
Waddington Galleries, London *(cat. 20)*

BOTTOM

Composition No. 15 *1972*
acrylic on canvas 93 × 133.5
Waddington Galleries, London *(cat. 22)*

</div>

operate in a similar way for the spectator if integrated into the painting in the same form. Photographs and decals were thus stuck directly onto the surface. By 1963, however, Phillips had come to desire a greater flexibility in his choice of material and now felt sufficiently confident of his technical capabilities to be able to transcribe more complicated images by hand. The solution he devised was to take his own photographs and then to transcribe them to the desired scale by projecting them directly onto the canvas. *SUPinsetER* and *INsuperSET* provide the initial instances of this 'first mechanization' of the artist. Phillips took photographs of details of pinball machines and then projected them as black and white negatives, as he later did in *Kewpie Doll,* giving the image a mysterious and rather sinister quality.

Rather than relying merely on what was already available, Phillips thus began at quite an early date to add to his arsenal of images by photographing them himself. 'I've got nothing against using any tool or piece of technology that is useful, and that is quicker than doing it some other way. To me there was no sense, when it came to using a projector, in trying to draw something exactly how it was just by copying it. When you want the image, you might as well photograph it and project it, then you're free to do with it as you want. If you want it exactly the same, which was usually the case, it was the most convenient way of doing it. And aesthetically rather interesting, because one can manipulate it in scale and reverse it, which you can't do just by thinking.'[1]

The precision with which the carburetors are depicted in *Auto-KUSTOMotive,* and the increased complexity with which the elements are interrelated, owe much to Phillips's new reliance on the projector. More or less every element in the picture was projected, from the English Ford Consul itself to the fragment of wording in heroic perspective. Phillips's long-standing fascination with interpenetrating spatial layers, implicit as early as *For Men Only - Starring MM and BB*, now takes on a new twist with the adaptation of 3D presentation techniques from advertisements and billboards. While making use, however, of the deliberately misleading come-ons employed by the graphic artist, Phillips destroys his own illusions by

consciously breaking into them; the most precisely-rendered elements, the carburetors, exist only as inserts rather than as parts of a complete mechanism, and the form of the car itself is abruptly truncated at both ends by the demands of the canvas construction. The space is deliberately confusing. Every element, of course, exists only as part of a flat surface.

Customizing was an American invention, a means of individualizing cars while at the same time suggesting their potential for speed by purely pictorial means. The appeal to Phillips was strong, for it provided an equivalent to the artist's own process of painting a canvas - in the dual sense of decorating a surface and of creating illusions - adapted to the requirements of a utilitarian object. In *AutoKUSTOMotive* an essential difference is suggested between the technology that goes into the making of machinery and the more traditional craft skills employed in customizing through a contrast in techniques. The equation with customizing is carried through to the materials themselves, since both the inset panels and striped image are painted with Kandy Kolor, a translucent automobile paint sold in cans and intended to be sprayed on polished metallic surfaces.

One must be cautious, however, about overstating Phillips's involvement with customizing, for it no more explains the qualities of the mid-sixties paintings than had the jukebox or pinball machine references in the earlier works. 'Customizing was a peripheral interest at the time', as the artist himself points out, 'but it wasn't the aesthetic behind the paintings specifically.' Cars and car parts feature in each of the eight *Custom Paintings* which Phillips began on his arrival in New York in September 1964 on a two-year Harkness Fellowship, but these continue to be combined with unrelated elements: labyrinths, diagrams of nuclear power stations and of a nineteenth century distillery, heraldic patterns from Battersea funfair, pin-ups, and an array of dazzling abstract patterns and geometric devices.

Although the last of the *Custom Paintings* was not completed until 1967, the entire series was planned in London in 1964 in the form of precisely worked-out drawings. 'This is the first time I started it, the first time where I made a direct logical organization of

SUPinsetER *1963*

INsuperSET *1963*

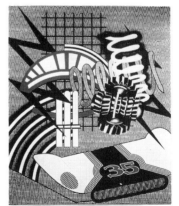

Custom Painting No. 4 *1964*

42

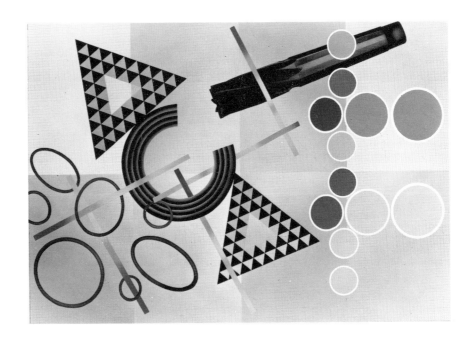

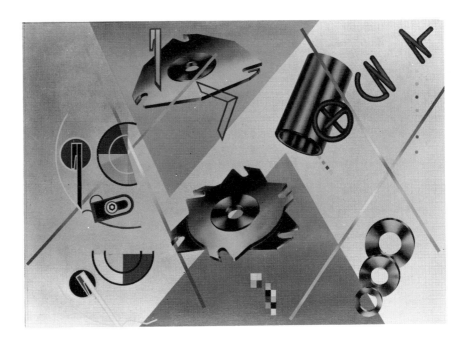

TOP

Composition No. 16 *1972*
acrylic on canvas 93 × 133.5
Galerie Neuendorf, Hamburg *(cat. 23)*

BOTTOM

Select-O-Mat Variation No. 4 *1973*
acrylic on canvas 93 × 133.5
Galerie Neuendorf, Hamburg *(cat. 24)*

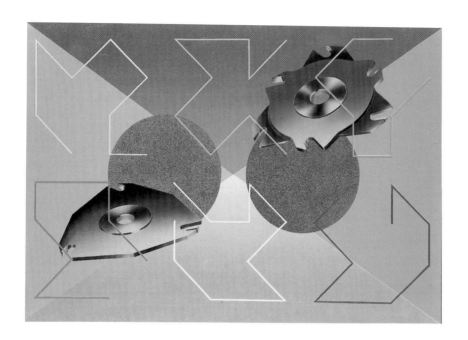

TOP

Select-O-Mat Variation No. 9 *1973*
acrylic on canvas 93 × 133.5
Galerie Neuendorf, Hamburg *(cat. 26)*

BOTTOM

Select-O-Mat Variation No. 10 *1973*
acrylic on canvas 93 × 133.5
Galerie Neuendorf, Hamburg *(cat. 27)*

TOP
Select·O·Mat Variation No. 14 *1974*
acrylic on aluminium 93 × 133.5
Galerie Neuendorf, Hamburg *(cat. 32)*

BOTTOM
Select·O·Mat Variation No. 16 *1974*
acrylic on canvas 93 × 133.5
Galerie Neuendorf, Hamburg *(cat. 33)*

TOP

Select-O-Mat Variation No. 7 _1973_
acrylic on canvas 93 × 133.5
Waddington Galleries, London _(cat. 25)_

BOTTOM

Select-O-Mat Variation No. 13 _1974_
acrylic on aluminium 93 × 133.5
Waddington Galleries, London _(cat. 31)_

46

the whole working procedure of making preparatory drawings in colour. I felt that obviously when I went to New York I would have a cultural shock and that I should take something with me so that I could get immediately to work.'¹ He took with him not only the drawings, but also the slides which he had used in

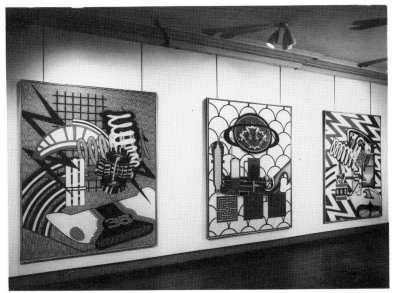

Installation view of **Custom Paintings,** Kornblee Gallery, New York, November *1965*

making them, which were projected again onto the canvases.

By 1962 Phillips had begun to eliminate the most obvious kind of handwork from his paintings, and the anonymity of image seemed increasingly to call for a comparable anonymity of technique. Having already begun to spray paint, the airbrush seemed an inevitable tool; the Fellowship now gave him the financial means to buy this and other equipment which he had been wanting to use for some time. Phillips was quoted in 1965 as praising airbrush artists as 'wonderful artists technically' with a lot to offer, adding that 'Technique can be aesthetic just as much as subject or anything else.'²⁹ One of the appeals of the instrument was that it lay outside the recognised canons of fine art.

'The airbrush is synonymous with certain types of imagery that one uses; it's an instrument that's used in technical illustration and graphic design. I could never understand why there was so much against it, because it really is a fascinating thing. Given a little bit of patience, eventually I could paint very rich areas of paint.'¹

More than ever before, Phillips's work now took on the character of painted collage, the airbrush providing a continuity of surface as seamless as that of Max Ernst's reprocessed collages. The homogeneity of technique neutralized the sudden ruptures of image, making it possible, for example, for an eighteenth century diagram to co-exist with twentieth century elements.

'I never saw any reason why anything is not valid or useful in a painting. Anything that happens to fit with my feeling for the painting. I'm not bound by any type of limitation other than the limitation of myself at that particular time, and that is a constantly-changing situation. It's not true to say that I'm concerned with high-tech imagery. . . I don't see anything wrong with taking from wherever I feel when it feels right, and age or period makes no great difference. It's a question of convenience, availability and accident.'¹

The figure in *Custom Painting No. 2* 1964/65, for instance, was taken ready-made from the airbrush manual with which Phillips was teaching himself the technique; the nude in *No. 5* 1965, by contrast, was from a pin-up magazine, drawn out with the aid of a projected slide and then painted in an invented scheme of black and pink.

'The figure is no more important than anything else in the painting. They're all recycled images which have been drawn by somebody else or reworked by somebody else. The car, too, has been retouched, and the machine parts have certainly been drawn out totally by somebody else.' Phillips perceives the figure as another neutral image, of no more interest than any other element. 'If I was concerned with the human condition of the figure, I would be painting totally different paintings.' The girls that he uses, as he himself points out, are generally removed in time, so that they have become pictures, not people. He selects them, it is true, because he likes them but this is the case with all his motifs. 'Why is it that machine and not another machine? Why is it always an automobile part and not a gas cooker or something? Every image is chosen by my personal preference. It makes no difference. . . Each particular element in that picture – and I call them "elements" – is a device, amongst many devices, to produce a painting.'¹

Phillips's attitude is not far removed from that of Léger, who

47

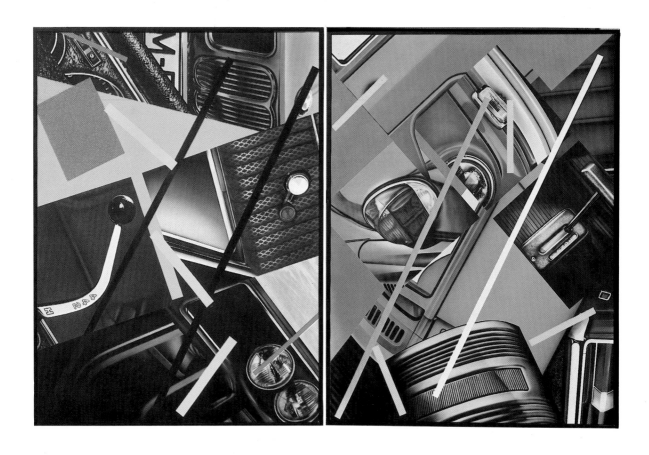

Automobilia *1973*
acrylic on canvas (2 panels) 200 × 300
Walker Art Gallery, Liverpool (Merseyside County Council) *(cat. 28)*

Fernand Léger: **Contraste d'Objets** *1930*
(© S.P.A.D.E.M. Paris, 1982)

wrote in 1952 that 'One may consider the human figure not for its sentimental value but only for its plastic value. That is why in the evolution of my work since 1905 until now the human figure has remained purposely inexpressive.'[30] The figures in *No. 5* and in later paintings by Phillips such as *Select-O-Mat Rear Axle* 1971 and *Art-O-Matic Cudacutie* 1972 recall Léger, too, in the way that they float arbitrarily against the painted ground.[31]

'Léger's things weren't earthbound. That's what interested me about his as opposite to Magritte's. Magritte's are always in a normal setting, apart from the very early pieces, and even then they were always a sort of half-landscape or something. It's interesting that Léger avoided the connotation of the usual Surrealist thing that it was a normal environment. It was their particular kick of putting something strange in a normal environment. I liked it when it was *out* of this.'[1]

Phillips devised his own system for producing the *Custom Paintings,* a method which he continued to elaborate until the mid-seventies. Using oil paint mixed with Magna – a medium which curtailed the drying time and thus made respraying more convenient – he first painted in the backgrounds, having marked off the image areas with masking tape and tissue paper. Designs such as the moiré pattern in *No. 4* 1965 were invented, sprayed in blocks with the aid of stencils cut by the artist. The more detailed areas were then painted in with the aid of projected slides. The shiny metallic surfaces, which provide an other wordly ground similar to that of the gold leaf on icons, were painted with regular artist's quality silver oil paint.

Although the *Custom Paintings* were all planned before Phillips's arrival in New York, visualized from the start as airbrushed pictures, the artist's experience in New York nevertheless instilled in him a respect for professionalism and an urge to take ideas to their final conclusion. 'I became more and more interested in making this total commitment to something. I think *that* I learned from America. . . I think that I took my basic ideas and I sort of doubled up and doubled up and doubled up on just how banal and aggressive I *can* get, and how clichéd I *can* get, and I took it to the extremes. I think to greater extremes than most of the Americans, because

I really worked with banality and painted it banal. They can be particularly nasty, because they're so totally uncompromising in every way, and using absolutely contemporary imagery. Some of the images, I think, didn't even get to the magazines before I used them, because I took them straight from the photographer who made the commercials. . . I was just very interested in seeing if I could make something from just opening a book and taking this out.'[2]

The notion of collaboration implicit in Phillips's work since 1960 – in his appropriation of techniques from commercial art as well as in his use of found material and of images reflecting popular taste – was reformulated in the *Custom Paintings* with the suggestion that art could be tailor-made to suit the requirements of a particular owner or of the public at large. This idea became the subject of a collaborative project on which Phillips began work in 1965 with the English artist Gerald Laing. Laing, who moved to New York in 1964 at the invitation of the dealer Richard Feigen and who had met Phillips briefly in London, was approached by Phillips with the idea of working together. Thinking at first along the lines of producing a joint painting, they decided instead to form themselves into a market research organization, Hybrid Enterprises, with the aim of producing an art object determined by the demands of the informed consumer.

Phillips and Laing together constructed two kits, containing samples of colours, patterns, shapes and materials – from canvas, paint, wood and fabrics through to modern synthetic and industrial materials such as plastics and metals – and devised a questionnaire, with the intention of feeding the results through a computer. The 137 people interviewed – mainly from New York, but also from London, Los Angeles, Chicago and other cities – were all critics, collectors, and arts administrators rather than artists. The computer was an integral part of the process, and thanks to the support of an influential art-lover the sophisticated set-up of the Bell Telephone Company headquarters was made available to them. Through their lack of experience with the technology involved, they found that they had framed the questions in such a manner that the results could scarcely be fed into the computer.

The colours, materials and dimensions were averaged mathematically, while the shapes had to be decided upon in a more subjective manner.

'There were contradictions, but we carried these contradictions all the way through. We had to interpret, but the materials and everything else that was there was demanded. It was a democratic art object. The majority vote got through... Using a computer was more of a gestural thing than an actual necessity. The whole thing was gestural; it was hardly a serious scientific analysis, but it was carried through to a logical conclusion.'[1]

Both Laing and Phillips admit frankly that the choice offered was not as free as the process might imply - there was, for instance, no real way of incorporating specific imagery, even though the interviewees were offered the alternatives of 'abstract' or 'figurative' - but their concern was with the process itself rather than with the particular form of the final piece. The resulting sculpture incorporated aluminium, plexiglass and a fluorescent tube within a wedge shape, the striped pattern at the side producing a chevron image with the aid of the reflective metal surface. Its composition, as Laing acknowledges, was 'an assemblage of trendy 60s notions', as well as an anticipation of the renewed popularity which sculpture was soon to enjoy in New York in the form of Minimal art.[32]

The question of whether the *Hybrid* sculpture qualifies as an art object does not worry Phillips. 'The gesture was the art. The object was the result of a gesture. Whether it is art or not is a question of individual interpretation, and that applies all the way through the last fifty years. Some people still don't even accept Picasso. What makes art, anyway: paint on canvas? That's no definition of art. I prefer to paint, but it's the process of building up ideas and extending the horizons - one should use every possible technical means, if it is in one's interests and availability. Other people probably don't even use masking tape. It's a personal choice. The results are what count. What ones does in between is hardly important.'[33]

Hybrid was presented with a deadpan irony befitting an object produced blatantly to the demands of the market, although Laing now speaks of the project as an 'attack on the way in which the New York art scene was being exploited', saying that the critic Gene Swenson was the only person who full grasped the corruption they were exposing.[34] 'The project was essentially satirical; it achieved its own life, so to speak, but when we started it we did not necessarily intend to carry it right to its conclusion... Commercial success was slightly surprising, and indicated the necessity of the project. In other words, clients hadn't got the faintest idea of what it was they were buying.'[32]

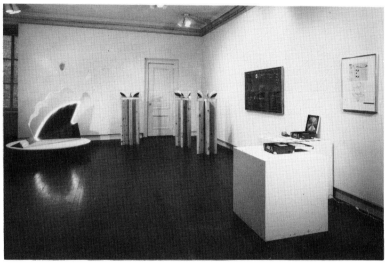

Installation view of *Hybrid*, Kornblee Gallery, New York, *1966*

Phillips agrees that the high sales of *Hybrid* - one of which was later acquired by the prestigious Fogg Art Museum at Harvard - confirmed the project, but says that 'One would have been equally as happy just to have carried through the gesture. That it was successful in these sort of terms afterwards and that it got enormous publicity, critical acclaim and censure and made *Life* magazine was very amusing, but that's just the state of the art world in New York. It was an amusing thing to do.'[1]

During the year that he was working on *Hybrid,* Phillips made a series of about six sculptures, his first and only excursions into the medium, some of which he showed in the *Primary Structures* exhibition at New York's Jewish Museum in 1966. Made of formica, plexiglass and lacquered wood panels slotted together, these constructions were more like relief paintings than sculptures, hanging on the wall but also resting on the floor. Only one of these works survives; the experiment was short-lived. 'I don't think the sculptures were as good as the paintings, and I couldn't see at that

Tiger-Tiger *1968*

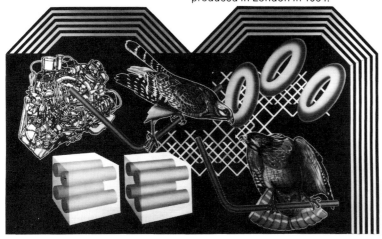

The Random Illusion No. 4 *1968*

particular stage how I could develop it any further. The use of other materials was interesting, industrial processes. It wasn't so far removed from the paintings, it was just that there was no figurative imagery; it was other types of imagery. At the time I wasn't capable of assessing the image content of my work in other terms.'[1]

Certain elements of these sculptures, however, such as the strips of coloured plexiglass, reappear in later paintings such as *Tiger-Tiger* and *SyncrojectoRAMA*, both executed in 1968, where they provide a decorative but physically substantial framework for the image. Having returned to Europe in 1966, Phillips took up painting where he had left off. The germ of the *Random Illusion* series, for example – a group of paintings made in 1968-69 – came from a drawing which Phillips had produced in London in 1964.

In view of the artist's continuity of purpose and procedure over the years, it cannot be said that his change of environment has had any significant effect on the content of his work. His decision to make his home abroad was made for personal reasons, including his marriage in 1970, with career considerations taking second place. 'I don't see why I should sacrifice my life for my art,' he commented recently, 'Picasso didn't.'[35] Nevertheless there is no denying that his prolonged absence from England has resulted in an unreasonable neglect of his work.[36] In spite of the fact that a retrospective exhibition of his paintings and drawings was held in Germany in 1972, until now he has been granted only a single one-man show in Britain (at the Waddington Galleries in 1976) and has taken part only sporadically in major survey shows organized here. In part, the artist admits, this isolation was self-imposed as a means of pursuing his work without the glare of publicity. 'I've avoided presenting myself publicly for a long time – since 1972. I was free enough to try things out, because I have not been under constant observation.'[1] During the whole of this period, Pop has been succeeded in critical fashion by Conceptual Art, Minimal Art, Performance Art, Land Art, Photo-Realism and New Image, to name only the most talked-about of the recent trends. Phillips has watched them all come and go and has responded to some of what they have to offer without allowing himself to be deflected from his fundamental purpose.

Phillips's work of the late sixties and early seventies takes to an extreme his interest at the time in anonymous surfaces and in a non-tactile use of paint. As early as 1965 he had spoken of his involvement with 'commercial techniques such as those that give the effect of a printed surface' similar to that of a glossy magazine.[20] As he later explained, however, his use of such techniques was occasioned not by an intellectual indentification with the mass media but with a direct visual response. 'If one chooses something from a magazine or from a poster, or what have you, this thing has technique, it has been made, and I'm particularly sympathetic to the way something looks before I choose that to use.'[37]

Although Phillips had produced his first screenprint in 1964 at the invitation of the Institute of Contemporary Arts, it was not until 1968, the year in which he produced his major portfolio *PNEUmatics,* that he experimented with the technique in his paintings. The engines in *Random Illusion No. 3* and *Random Illusion No. 4* are both screenprinted in black and then touched up by hand. The technique did not hold Phillips's interest for long, partly because four-colour screenprinting, which he would have preferred, would have been too expensive, but also because silkscreened images had already been used by Warhol and Rauschenberg. 'It wasn't what I wanted and it had already been done so often that it became an aesthetic in itself, and it would be misinterpreted.'[1] Phillips found that he had more flexibility with the airbrush alone. The only change from the pre-

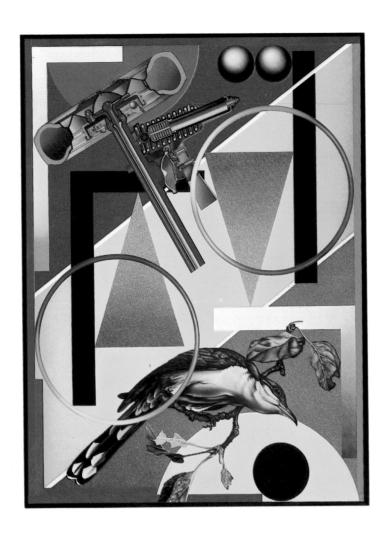

Art-O-Matic Blue Moon *1973*
acrylic and metallic jewels on canvas 200 × 150
Lindenmeyer collection *(cat. 29)*

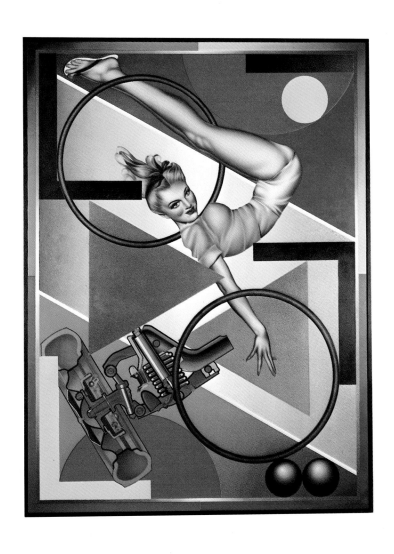

Art-O-Matic Riding High *1973*
acrylic on canvas 200 × 150
Claude Phillips *(cat. 30)*

vious airbrushed paintings was one from oil to acrylic paint and tempera, a practical necessity as Magna was not easily obtainable in Europe and there was no other compatible medium at that time. Tempera was used for areas in which delicate spraying was required, as it atomized more finely than acrylic and had less tendency to clog up the needle.[38]

The *Random Illusion* series grew out of a plan to produce a group of interrelated paintings, each utilizing the same categories of imagery, the same format, and the same basic approach. In each case the tightly-defined images are displayed against a black background (*No. 6* being the sole exception) and encased within a framing device constructed of strips of coloured plexiglass or of lacquered wood. In structure one side of the painting is the exact mirror image of the other, although the use of a striped border along the right edge alone creates an impression of asymmetry. This establishes one form of illusion, the others arising from the *trompe-l'oeil* replication of found images and from the presentation of geometric and machine forms in perspective.

As always, the types of images used - diagrams of molecular structures and the like from the pages of *Scientific American,* predatory birds by the American nineteenth century artist John James Audubon, motor engines and machine parts, and invented grid patterns - have been selected with a view to their emotional resonance when juxtaposed.[39] The repetition of similar images from one picture to the next, chosen at random from the available material, creates a range of limitations for that particular sequence of paintings. Phillips considered using photographs as reference material for the birds, but settled on Audubon's ready-made illustrations as more convenient and appropriate. 'The photographic image just didn't feel right. The definition wasn't there, and it didn't match the images that I was using . . . I think I could have found something equally dramatic in photographs, but I would have had to spend a lot of time refining the photographs. Whereas Audubon I could just take as it was, and it was rather nice to use that.'[1] Each illustration taken from *Birds of America* was accepted as the material for a particular painting - if two birds appear, both are used - and is copied as faithfully as possible in terms of colour and detail. Some-

times, however, the image is reversed or the spacing between the two elements is altered according to the requirements of the picture.[40]

The penultimate painting in the *Random Illusion* series, *No. 6* 1969, introduces further devices for increasing the dynamism of the picture. It is larger in scale and brings in additional images (a full car and a group of grossly enlarged lipsticks), a brilliant yellow background and a shaped projection along the lower edge. In the following year Phillips began a group of enormous canvases, three of them over sixteen feet in width, which took these characteristics further yet, summarizing in the most extreme form the artist's concern with impact through scale, aggressiveness of image and complexity of spatial interweaving: *Front Axle* 1970, *Select-O-Mat Rear Axle* 1971, *Select-O-Mat Techtotempest* 1971, *Art-O-Matic Cudacutie* 1972 and *Art-O-Matic Loop di Loop* 1972.

Tempting as it is to perceive the overwhelming qualities of these gigantic canvases as a Pop artist's act of defiance towards the art world, which by this time had embraced both Minimalism and Conceptual Art, Phillips maintains that he was not motivated by such external considerations but only by the internal logic of his own work. It was only in 1970, when he moved into a huge new studio in a disused factory, that the possibility of working on such a large scale presented itself. Phillips installed airguns on overhead lines so that they could be easily moved, and had big ventilators to clear the air of the impurities caused by spraying. Since about 1968 he had also tried using assistants, at one stage employing two, to help with the mechanical work such as mixing colours, masking and filling in, in the hope of increasing his production. Unlike artists such as Paolozzi, who have viewed the making of their work by others as part of their technological aesthetic, Phillips considered the use of assistants simply as a convenience. Had he been able to afford airbrush specialists, he would have hired them out of deference to their technical expertise, but he had no intention of delegating any of the decisions to others. He stopped using assistants when he found that they were not making a significant difference to the amount of work he could get through.

Another practical consideration which relates to the increased com-

Christmas Eve *1968 (screenprint)*

SUNgleam *1968* (screenprint)

plexity of Phillips's work from 1970 was his construction in that year of the Select-O-Mat, an image bank made according to his own specifications which incorporated ten miniature back-projection screens and ten projectors. Information was recorded in the form of 35mm slides, each bearing a separate number to allow for rapid scanning and retrieval, with the possibility of comparing ten separate images at once. There was no possibility of printing out the images; it was simply a way of sorting through the material in a more systematic manner.

'It was just another gesture', says Phillips now of the Select-O-Mat. 'It was a waste of money, but it was something that I felt I had to continue with the whole process of working.'[1] He dismantled the apparatus in 1974, having used it for the series of small *Compositions* and *Select-O-Mat Variations,* and has not had recourse to it again. The implications of random selection from a wide range of imagery, however, have continued to interest him. Phillips stated his position clearly, though not without irony, in the form of an advertisement for the 'Phillips Select-O-Mat' on the last page of the catalogue for his 1972 Münster retrospective. 'Your Choice', reads the advertisement, 'Plus standard options, mated together to just exactly the right configuration.' Reproduced alongside is a varied range of images - mechanical parts, diagrams, a customized Plymouth and pin-ups - several of which feature in Phillips's paintings of the time.

Select-O-Mat Rear Axle *1971*

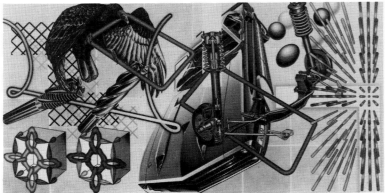

Front Axle *1970*

'That was a presentation idea. The idea was for me to walk around with my little case full of goodies and say, "Here you are, sir", and you'd show him everything and he'd say, "I'd like that and that and that". And I'd go click click click and that was that. It was a statement I wanted to make of my anonymous position.

That anything, it didn't really matter, could work in this painting . . . and that your choice is no more important than my particular choice.'[33] Phillips's thinly-veiled but deadly serious proposal was taken up by only one collector, who commissioned a group portrait of his family in a *Mosaikbild* format in the mid-seventies. 'We discussed what he particularly wanted, so with my own gentle irony I did exactly that and the customer was very satisfied.'[1] If the gesture seems extreme to us today, it is only because we have become accustomed to the idea of the artist as an eccentric individual responsible to no one but himself. Phillips's recognition of the possibility of working to a patron's demands merely takes into account the traditional rôle occupied by artists until the end of the nineteenth century.

The images employed in *Front Axle* and the subsequent mammoth canvases are of essentially the same kind used in Phillips's earlier paintings: shiny new cars, seventeenth century spectrum diagrams, scientific illustrations, machine parts, birds and women, all arrayed with flagrant disregard of the laws of gravity against the background of a coloured grid or of a dynamic pattern based on a found diagram.[41] The vulgarity is taken to a deliberate extreme, nowhere more so than in the case of *Rear Axle*'s mindlessly grinning nude, her balloon-like breasts seeming to bear her afloat. Sleek machine-made objects are thrust towards us as beautiful and desirable commodities. Phillips is adamant that his paintings were never intended as celebrations of 'technicolour culture', but accepts that the materialistic streak of his work in the sixties and early seventies might have had subconscious origins. 'Again it comes from the background, an industrial background, from being poor and having certain materialistic desires which I must admit are now saturated and satisfied, but were perhaps necessary. I don't know how important that was, I can't say. That would be easier for an outsider to say.'[1]

In Phillips's own estimation the large *Art-O-Matic* paintings of 1972 were the cumulative statement of the aesthetic which he had established eight years earlier in taking up the airbrush. Feeling that he had made his statement, he now began work on a series of much smaller standard-

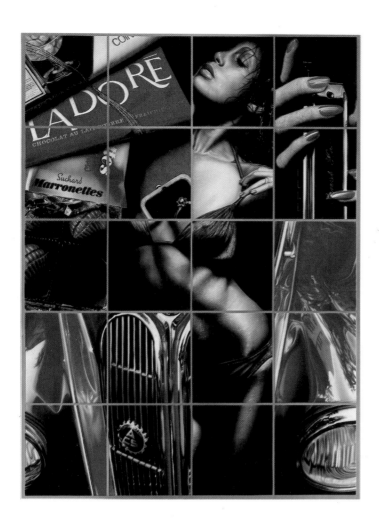

Mosaikbild 5 x 4/La Doré *1975*
oil on canvas 200 × 150
Lindenmeyer collection *(cat. 34)*

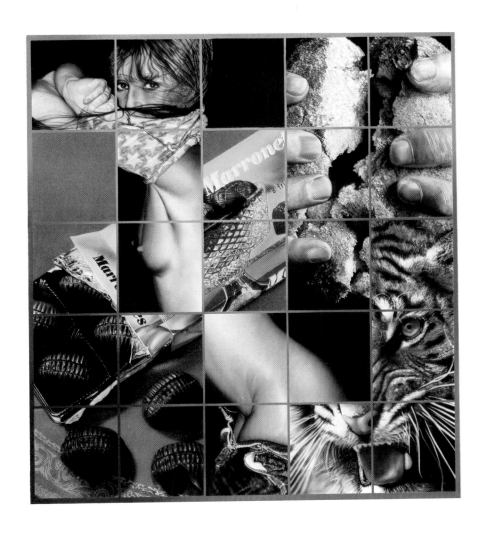

Mosaikbild 5x5/Supergirl *1975*
oil on canvas 200 × 200
O. R. Triebold *(cat. 35)*

sized canvases as a means of 'winding down'. In all about forty or fifty *Compositions* and *Select-O-Mat Variations* were produced, turned out quickly 'like real machine productions' according to a set system, without the aid of preliminary drawings. 'I could have done another five hundred, but I had enough. Having made your gesture along those lines of machine belt production, with loads of variations and working out exactly how you're going to do it, there's no point in going on.'

The choice of *Composition* as a title reflects the emptying out of the most blatant kinds of images, the impact provided now solely by the conjunction of mechanical with brightly-coloured geometric elements, but in essence they are no more and no less abstract than the preceding paintings. 'From this point of view, *all* the paintings are abstract paintings. From that I mean that there's no image which gives you any insight into my paintings or into my working principles, because they're all equal, and when they're all equal they become, in these terms, abstract. But I hate the word abstract, it doesn't mean anything. It's just a word of convenience. There's nothing abstract about these paintings.' Phillips acknowledges, however, that he had begun to reassess the content of his work. 'At this stage now I was beginning to become worried about impersonal surface, and I was starting to become worried about the nature of the image. I was slowly becoming aware of other feelings that I had that I was not bringing out, and I was slowly becoming stuck to a certain extent. This was like the end of the whole machine work.'[1]

The *Compositions* and *Select-O-Mat Variations* bear no signs of a change of heart. In spite of their small scale, they are endowed with great presence through their clarity of form and colour, rightness of placement, and spatial complexity. Painted in some cases with glitter on aluminium and sealed with a tough acrylic varnish, they have the strangely seductive beauty of well-made machines. Like the large canvases which preceded them, they also reveal a number of affinities with the late work of Kandinsky, which Phillips has long admired: in their geometric scaffolding, in the scattering of images against patterned grounds in vivid hues, in the spatial contradictions of multiple interpene-

trating planes, and even in the choice of a panoramic format. Each picture provides an emotionally intense spectacle for the senses. The machine, which had been introduced subconsciously as a stand-in for the figure as early as *Motorpsycho/Tiger* 1962, continues to perform an implicitly human rôle, with drill bits, coils and springs appearing to act out a ritualistic sexual drama. In a literal sense, however, every element continues to represent nothing but itself. Any further meanings which the paintings may suggest are not part of a symbolic programme, but arise from the connotations of the objects represented.

The Münster retrospective in 1972 provided Phillips with the opportunity to reassess his position. Feeling that he had exhausted the possibilities of the positive ready-made image but wishing to retain the substance of his working methods, he began in 1973 to look for ways out of his self-imposed cul-de-sac that would allow him greater flexibility without changing him into 'an unrecognizable person'. In order to give himself greater freedom to experiment, he decided for the time being to keep himself out of the public eye, taking part in no exhibitions until 1974.

At the end of 1972 Phillips spent the Christmas holidays in the Swiss mountains, where he made a series of collages incorporating fragments of automobile parts. On returning home he began work on two separate canvases based on these collages, deciding in the end to join them as a diptych. The resulting painting, *Automobilia* 1973, reveals more straightforwardly than ever before the collage origins of Phillips's work.

'I've always liked the idea of a painted collage. It applies very well, somehow, to the way I work. When you're dealing with imagery that is relatively precise, but you're also dealing with other relationships, you can't really mess about on the canvas. Otherwise, as in the early days, I'm going to be spending ages to get a painting right. I can't spend a week painting an image and then decide I want to move it two inches in the other direction.'

Although *Automobilia* was the first of a proposed series, the remaining works never materialized. In hindsight Phillips recognizes it as a major painting in his development, one which holds the seeds of his present working methods, but at the time it looked so different to him from his

Love Birds *1974*

Wassily Kandinsky: **Composition IX** *1936* (© A.D.A.G.P. Paris, 1982)

Carnival *1977*
oil on canvas 220 × 120
the artist *(cat. 37)*

Solitaire is the Only Game in Town *1976*
acrylic and oil on canvas 250 × 125
Galerie Neuendorf, Hamburg *(cat. 36)*

Flowers & Chain *1978*
oil on canvas 100 × 100
private collection *(cat. 38)*

other work that he could see no way of pursuing this particular line. The fact that the imagery, while drawn from unrelated sources - there are fragments of a BMW, a Volkswagen beetle, a Volkswagen bus and of the interior and exterior of several unidentifiable American cars - linked up thematically may also have been one of the causes of his uncertainty.

A central issue underlying Phillips's doubts in the mid-seventies was that of his self-imposed rule of anonymity of surface. He was beginning to miss the sensual qualities of paint, and in *Art-O-Matic Riding High* 1973/74 - a canvas which in its format and range of elements pairs with *Art-O-Matic Blue Moon* 1973 - he began hesitantly to use a brush again, rather than relying solely on the airbrush.

Phillips's thoughts about abandoning the airbrush, however, were short lived, for in 1974, motivated in part by a spirit of competition with the newly-arrived Photo-Realist movement,[42] he returned to non-tactile paint, with a particular emphasis on the qualities of a photographic surface. With a diversity of illusionistically-rendered interlocking images contained within the stabilizing format of a regular grid, the *Mosaikbild* paintings of 1974–76 are in certain respects the most technically dazzling pictures that Phillips has produced.

'Photo-Realism came along and this disturbed me because it did produce another aspect of highly technicized paintings done very, very well . . . When I went to New York, I looked up Chuck Close and Ben Schonzeit out of pure curiosity about how these guys worked, because they were both using airbrushes and in such a way that made me look like a fumbling amateur in terms of technique. And technique still fascinated me. So I felt that somewhere down the line I had to try, at least, but certainly not just painting a photograph . . . It was so banal, but the surfaces, and the use of the airbrush, were so incredible: the sensuousness that everybody else would find not sensuous, but I found tremendously sensuous, made me rethink a little bit.'

The example of Photo-Realism spurred Phillips to return to the photograph in place of the diagrammatic elements he had been using. 'I felt that I had to update everything, and I was obviously very wrong in that, but the paintings worked OK. The photograph as such was a mistake, and I also made what I would now consider a mistake with the definition of the image, in such a way that I still wasn't solving my problem. I was only giving myself more problems, in fact, but I didn't realize it at the time. I thought that by a change of nature of image - the process remaining the same - from the diagrammatic to the photographic, I'd broaden my range of

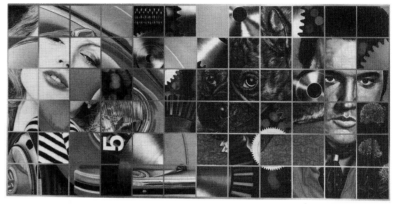

Mosaikbild 6 x 12 *1974*

imagery so that I wouldn't become again closed into this system of working. In fact all I did was change one prison cell for the next prison cell, so to speak. But I learned a lot

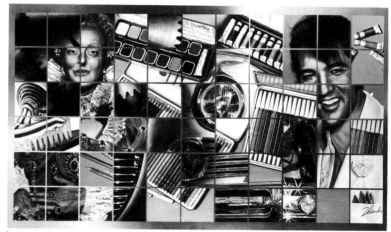

Mosaikbild 6 x 11 *1975*

from doing it. Some of the paintings were OK and I was able to carry on.'[1]

The basic elements of *Mosaikbild 6 x 12* 1974, the first of the series, can be traced back to Phillips's earlier work. The use of a grid as a compositional device, for instance, occurs as early as *Purple Flag* 1960 and features prominently as a ground in the huge canvases of the early seventies. The display of fragments of images across the surface, and the playing off of one spatial system against another, are likewise common features of Phillips's work. This is the first instance, however, in

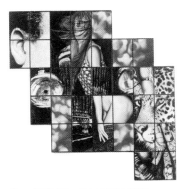

Mosaikbild/Displacements *1976*

which the fragments of positively-rendered images interpenetrate each other *through* the grid. The resulting change in the form of the painting is considerable.

In view of the way in which the Select-O-Mat apparatus prefigured the form of the *Mosaikbild* paintings, it is ironic that it was only recently that Phillips had dismantled this ten-screen back-projection unit. The solution for the paintings came not from the Select-O-Mat but from a newly-introduced device called Multi-Vision, which Phillips came across by accident in a camera exhibition in Zürich. Consisting of a series of computer-guided back-projection units, Multi-Vision was designed to present a sequence of pictures which could be overlapped, fragmented, or presented whole. Although Phillips did not see such a mechanism in operation but learned about it from a book, it appealed to him immediately as another product of technology intended for use outside of a fine art context. It struck him as a good way of formally approaching a picture using photographic imagery, one which, moreover, provided an alternative to the intuitive balancing of elements on which he had previously relied.[43]

Having first experimented with the grid form in some small collages, Phillips set to work on *Mosaikbild 6 x 12* in an impromptu fashion, with no preconceived ideas about the imagery he would use. The entire canvas was taped up to form the grid, with the areas around the boxes to be sprayed masked off. Starting at random with the image of the dog, Phillips decided to use only those sections of the picture which had interesting or readable information. The selection of which squares to fill with subsequent images was made in a similar fashion until all the squares were filled. The bust-length portrait of Elvis Presley was added last, not out of any particular interest in the subject but as an image which filled the area conveniently.

Since it was not necessary for the painting to have the immediate legibility required in normal Multi-Vision, Phillips felt free to exaggerate the implicit notion of simultaneity. As a result, even the smaller of the *Mosaikbild* pictures such as *La Doré* and *Supergirl* teem dizzyingly with abrupt breaks and unexpected juxtapositions, stopping just this side of claustrophobic congestion. Thanks once again to the homo-geneity of surface, all these contra-dictory types of space and of illusion are made to coexist.

La Doré and *Supergirl* are distinguished from the rest of the series by their particular surface qualities. First of all the canvas was sanded down until it was completely smooth. The new variety of artificial Dutch paint with which they were then sprayed has the characteristics of gloss or automobile paint but with a greater intensity and depth of colour, thanks to the admixture of fine pigments. The layer of protective varnish, which Phillips used to tone down the glossiness of the paint, gives the surface a satin finish which was ideal for Phillips's purposes at the time. Exaggerated in colour and sleek in finish, the result approx-imates in a fitting manner the appear-ance of a photograph.[44]

Phillips's return to a photographic in place of a diagrammatic image in the *Mosaikbild* series brought him back to the same kind of motifs which he had been using prior to the *Compositions* of 1972 – cars, pin-ups, animals, advertising imagery – though treated in a different manner. Previously he had masked the area around the images to get a high definition, but he had now come to the conclusion that the hard edges which resulted were not appropriate, because 'things *aren't* comprised of hard edges.'[1] He settled instead for a stunning surface effect, accepting as its price the blurring of form around the edges.

It was at this time also that Phillips began to use his own high-definition photographs as reference material for the paintings. As long ago as 1963 Phillips had been taking his own photographs as a means of adding to his armoury of images, in works such as *SUPinsetER* and *INsuperSET*. In those days, however, it was as a mat-ter of convenience only that he took 35mm slides of material that had already been processed into two dimensions – for example, the designs on pinball machines, or dia-grams and illustrations from books and magazines – so that it could be projected onto the canvas and copied out. Since 1975, however, Phillips has been prepared to 'manufacture' his own 'found' material, choosing the actual objects he wants to use and having them photographed pro-fessionally under carefully controlled conditions with a large format camera. This gives him not only greater flexibility in the choice of

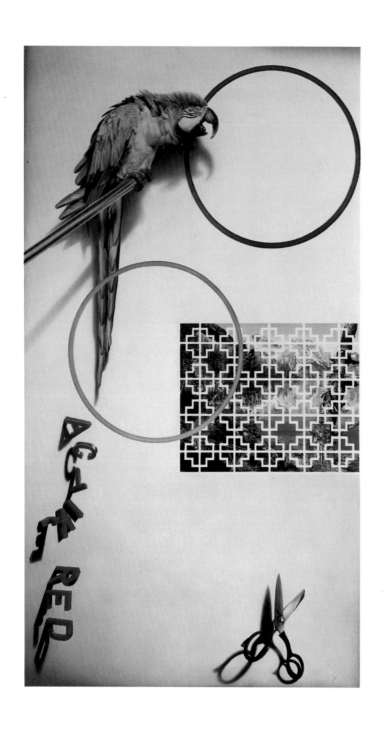

No Focus Frames *1976/77*
oil on canvas 220 × 120
private collection *(not in exhibition)*

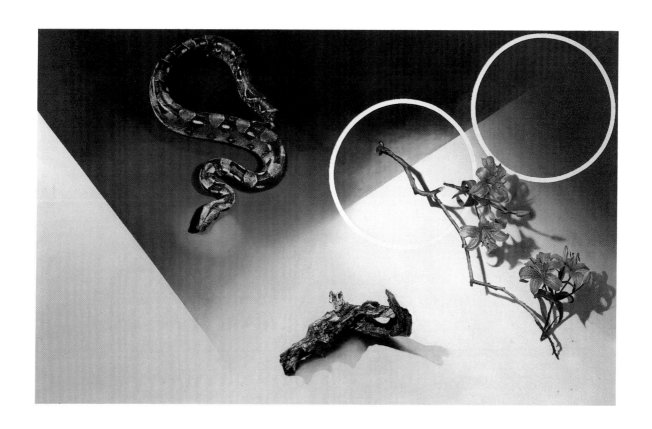

Mediator 1 *1979*
oil on canvas 135 × 220
Dr. R. Müller *(cat. 39)*

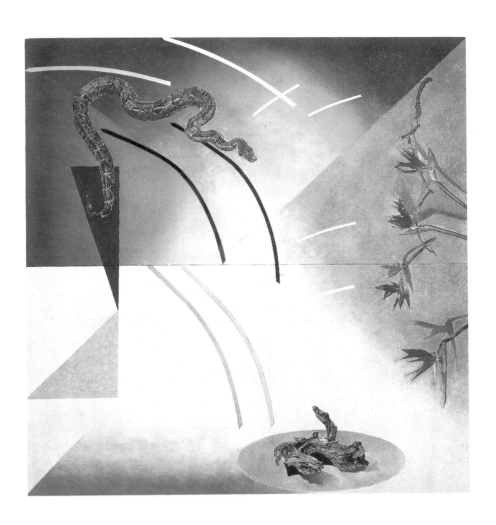

Mediator 2 *1979*
oil on canvas 180 × 180
private collection *(cat. 40)*

Classifications May Vary *1976/77*

Untitled *1976/77*

image and of its particular configurations, but also a much finer degree of detail. Whether the image be of a flower, a parrot or a snake, however, every motif has been translated into two dimensions before the painting is begun. Nothing is painted directly from life. No fundamental change, in other words, has taken place in Phillips's manner of working.

The first paintings based on this kind of high-definition photograph, *Mosaikbild 5 x 5/Supergirl* 1975 and *Mosaikbild/Displacements* 1976, were occasioned by personal considerations. 'My wife Claude said to me once, "You're always painting women, why don't you ever paint me?" So being a nice guy I said, "Okay, why not?" She looks okay, she looks as good as all the pin-up girls. I took her to a photographer's studio and photographed her with a professional pin-up photographer. I got a load of photographs, then I chose again in the same way the ones that appealed to me, and put them in the painting. So the process, in fact, is no different. It was just a question of a personal thing with Claude, but there's no great difference. Instead of a found object, she became, in a sense, an archetype for all of these things. They're images for all images.'[1]

Although the kinds of images pictured in the *Mosaikbild* paintings were as much a part of life in 1974 as they had been in the early 1960s, Phillips recognized that the cultural situation had changed and that such material had begun to outwear its usefulness for him. Early in 1976, a week before the grid paintings were exhibited at the Waddington Galleries, Phillips spoke of his desire to change the direction of his work:

'I don't want to backtrack. I think that there are uncountable possibilities still, but I think that they have to be said in other ways.' Aware that his use of the airbrush had hardened into a formula, he felt the need to reintroduce a degree of ambiguity into his work. 'I begin to feel that it's a mistake, generally, to make something *too* obvious, because it doesn't feed the intellect or the feeling. This, I think, is also one of the downfalls of certain types of American painting, that it was all there for you. That was the point of people like Stella, Noland, and the Minimalists . . . I think when it's just there, there's nothing left. The world is full of artefacts, and once it's been said, I can't see any reason to go on saying it.

And this is something that I have with my own work, that doesn't apply to the other people but that applies to certain elements of my own painting, of having made it so bloody obvious.'[2]

One of the paintings shown in the Waddington exhibition, *Solitaire is the Only Game in Town* 1976, is cited by Phillips as proof of the changes that he was beginning to impose on his work. 'I was very concerned not only with the nature of the image, but with the nature of the thing in general. I didn't like it full of these photographic things, so we got this simpler blank canvas with things, which is not unrelated to my new paintings, except that the image is still hard and defined. I went through this whole period, then, of seeking new combinations of different imagery.'[1]

On moving into a new house and studio in 1976, Phillips began work on a group of paintings that were formulated in direct reaction to the *Mosaikbild* series. The shared characteristics of paintings such as *No Focus Frames* 1976/77, *Classifications May Vary* 1976/77, *Untitled* 1976/77, *Rustic Ice Ray* 1977, *Greetings* 1977 and *Carnival* 1977 make it possible to view these as a self-contained series. The grid structure, which Phillips had come to view as a trap, has now given way to a field of modulated colour which provides, as in his paintings of the early sixties, space in which to relate the various elements. In place of the claustrophobic clutter of interpenetrating images – which, apart from anything else, involved the slow and tedious work of producing a uniform finish – a similarly active surface is now achieved through the scattering of points of focus.

Apart from areas of colour modulation by glazing, the airbrush was hardly used in the making of these paintings. The highly-detailed images were all painted with extremely fine brushes, with many of the motifs transcribed with the aid of an epidiascope from large format high-definition colour transparencies taken under the artist's direction. 'Having gone to such lengths with the airbrush before, I felt that I needed to learn how to highly define an image. I still was not certain about my image but I knew that there was something wrong, so I was changing the image. But paintings that looked like photographs weren't right. I wanted them to have more solidity.'[1]

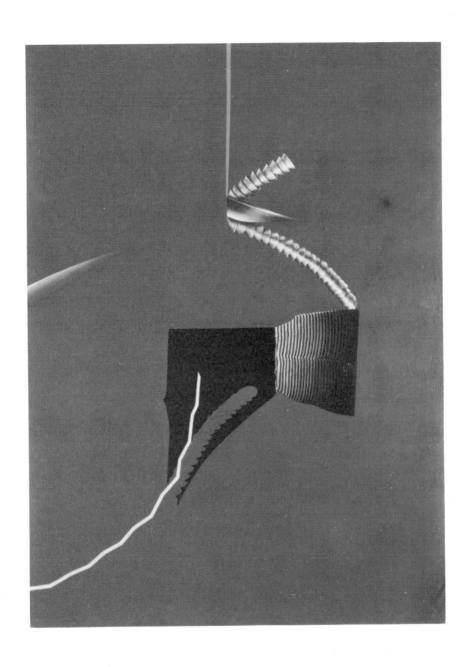

Roadrunner *1980*
modelling paste, acrylic, oil and wax on canvas 214 × 160
Lindenmeyer collection *(cat. 41)*

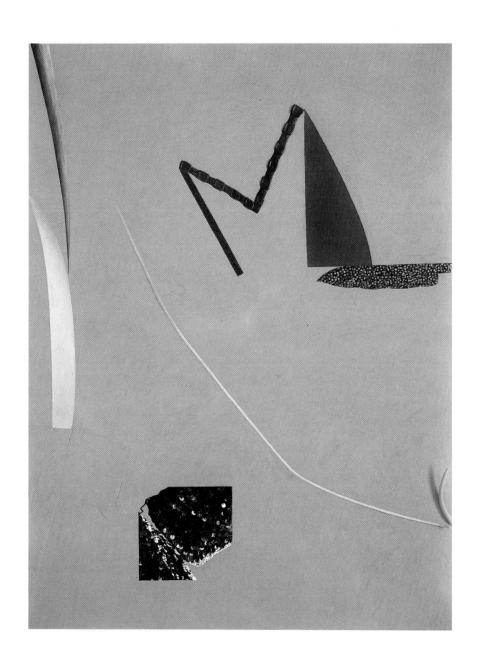

The Pink One *1980*
modelling paste, acrylic, oil and wax on canvas 214 × 160
Claude and Zoé Phillips *(cat. 42)*

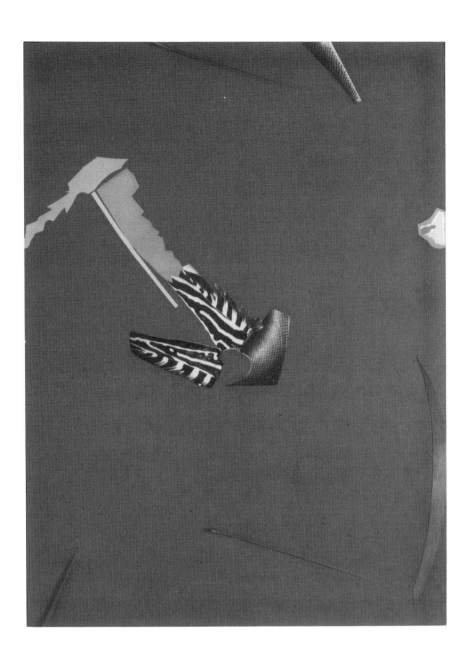

Repetition of a Night-Time Safari *1980*
modelling paste, acrylic, oil and wax on canvas 214 × 160
Waddington Galleries, London *(cat. 43)*

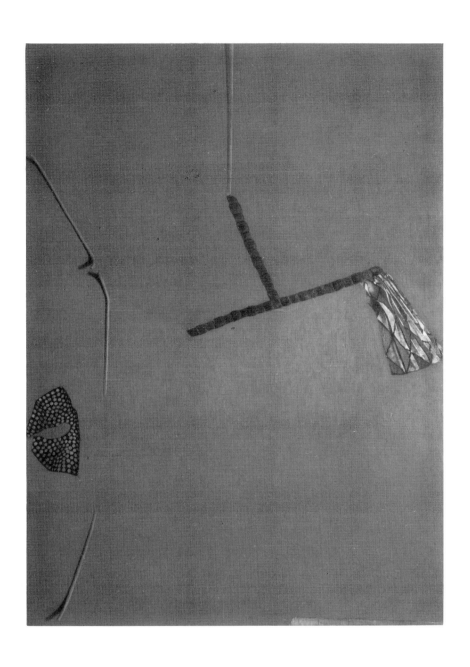

Aboriginal *1980*
modelling paste, acrylic, oil and wax on canvas 214 × 160
Galerie Ziegler, Zürich *(cat. 44)*

Even before returning to hand-brushed surfaces, Phillips had begun to look closely again at Old Master paintings, admiring in particular the *trompe-l'oeil* effects achieved by seventeenth century Dutch artists such as the still life painter de Heem. Phillips revealed in early 1976 that one of the spurs for looking at earlier art was the lack of visual stimulation provided by recent developments such as Conceptual Art, the ideas of which he thought were intriguing but the form of which he found unsatisfying. 'It leaves me rather empty, so I find myself now going and looking at paintings that I've never looked at, but particularly paintings. I spend most of my time in a national gallery when I go to a city . . . which is fascinating. Probably because there's such a time difference that I don't understand, anyway, so that there's a fantastic mystery there in the beginning. But the paint is a whole other thing in itself.'

The introduction of a more tactile quality to the paint surface, still tightly controlled, but evidently hand-worked, is only one of several new features to appear in paintings such as *No Focus Frames.* Although every image is treated in a positive fashion as given material to be reproduced without alteration, a clear differentiation is now made between those elements which have been found ready-made, such as the Alpine landscape view, and those which have been photographed under the artist's direction, such as the parrot, scissors and lettering. The found element is presented as a flat photograph, thus denying its own illusionism. The elements devised by the artist, on the other hand, have been photographed under a strong light, thus casting strong shadows which, when reproduced in paint, reinforce the sense of *trompe-l'oeil* realism with which the objects are depicted.

The shadows, moreover, introduce a different kind of space to Phillips's paintings, a specific enclosed space rather than the ambiguously-defined shallow space of the late sixties and early seventies paintings. The pocket of space which is thus created around each object is flattened out again as soon as one's eye moves away from that image, producing a series of spatial jumps which give the surface a great tension and vitality. It is as if the painted background were a kind of weightless no-man's land, with each image as a planet with its own gravi-

tational pull, a potent metaphor for the inexplicable fascination exerted by painted representations of ordinary things.

The unexplained light source and sharp shadows in Phillips's paintings of the late seventies are as ominous and threatening as those in a Hitchcock thriller. This is no longer the specifically urban menace of the early work, but a more generalized psychological tension. Some of the imagery, it is true, is fairly obvious in its connotations – open scissors poised for violence, insect and animal-like tools, a writhing female python, and in the case of *Carnival* a masked head and gloved hands – but this does not explain why even the lilies of the two *Untitled* 1978 paintings are not tame and pretty flowers but spiky, evil-looking objects. It would be wrong, moreover, to ascribe too conscious an intention on Phillips's part, for the initial appearance of flowers in his work was not his own choice but that of the collector who commissioned the picture. 'It doesn't make any difference to me', Phillips remarked a year later, 'because I'm not attached to these things.'[33] Conscious, however, that flower imagery was almost repellent to many people as something bordering on kitsch, he remarked that this added to his interest in the motif rather than detracting from it.[45]

'I can't psychoanalyze myself in my own work', explained the artist in October 1979. 'That's probably why I just paint snakes', the implication being that the subject was as good as any other. The python, after all, offered to him as a model by an acquaintance, had recently shed her skin and thus looked particularly beautiful. In the same conversation, however, Phillips bemoaned at length the cynical manipulation of the art world, the lack of any real contact with art on the part of the public, and the doubts that beset any artist, no matter how dedicated, about the importance of his own work in a wider social context. Assailed by the apparent bleakness of the situation, the artist asked rhetorically, 'Is it just that I'm going through a depressive period?'[33]

If the pair of *Mediator* paintings and related works of the late seventies reflect this despair, however, it was not that the artist was making a deliberate statement but that his work, as always, was based in his own subjective outlook. 'The painting

Rustic Ice Ray *1977*

Greetings *1977*

Half the O in Vogue *1980/81*
modelling paste, acrylic, oil and wax on canvas 214 × 160
Dr. R. Müller *(cat. 45)*

Gemini 2: Purpose and Passiveness *1981*
oil and wax on canvas (2 panels) 180 × 260
the artist *(cat. 47)*

Untitled *1978*

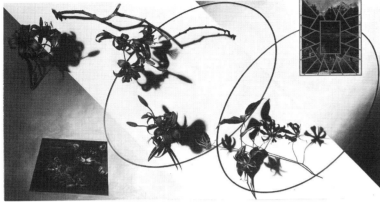

Untitled *1978*

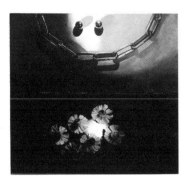

Fibre Light *1979*

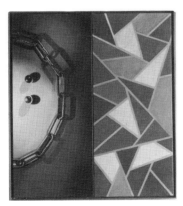

Balls & Chain No. 1 *1979*

has no symbolic implications because it was derived, like all the other paintings, emotionally . . . Symbolism is a rather serious and complicated science and art. You can't just shuffle around on the outside of it. It's better to do it, as Jung would have preferred it, from the unconscious. As soon as you become programmed, it loses its potency.

There's nothing wrong later in describing it from an unconscious point of view. Say one reads through related material and comes across a word reference that somehow fits with that, then it's right; then you say, "Okay, that's for that." But it's again an unconscious selection, which is a similar activity to the painting.'

The sense that the *Mediator* paintings, in particular, might have hidden meanings was not lost on the artist, who had worked on them obsessively for a period of months. On finishing them he consulted a dictionary of symbols to try to make some sense of them for himself, and found in this source a title for the paintings which seemed appropriate.[46] 'I started to become involved afterwards, when they became obvious. It looked rather symbolic so I started to check it all out. It still didn't mean very much to me, anyway, so I preferred to leave it. It's there, it came out, and it's over with, whatever it was. Perhaps it was a rather peculiar period, but it's gone now.'[1] As soon as he became aware that the lilies and snakes would be misinterpreted, he abandoned them, just as he had discarded earlier obsessive images when intuitive choice was in danger of becoming codified.

Phillips has always been his own most severe critic, and the changes in his work inevitably can be accounted for by his urge to approach the same range of issues from different points of view. Feeling that there was still a disjunction in his paintings between image and coloured background, the artist began to experiment with coloured spotlights on objects as a means of fusing object and ground in a more direct manner. *Flowers and Chain* 1978 and *Balls and Chain No. 1* 1978 are two of a group of paintings which he produced using this system, each a maximum of one metre square and featuring a deliberately limited range of props including a twig, feathers, screws, metal balls, a chain and flowers. Once again Phillips availed himself of a technical apparatus, a set of miniature fibre lights in primary colours which can be focused and optically mixed; a tool intended for commercial photography, it was purchased by Phillips ready-made.

The system employed was a straightforward one. Objects were placed in position, the lights were manipulated to the desired colour and position, and the resulting configuration was then photographed. The colour transparency, projected with an epidiascope, supplied all the necessary information for the painting, so that no further decisions regarding composition, colour or image had to be made. The artist was thus left free to concentrate on working the surface to a seductive density. The only limitation, governed by the range of lights he was working with, was that the objects had to be fairly small. As Phillips had made the decision to paint each object at approximately life size, with the canvas transcribed from a single transparency, this meant that there was a built-in restriction in terms of the canvas format that could be used. Given a larger set of fibre lights, however, greater flexibility of scale could be achieved.

Having introduced shadows into his paintings, Phillips now treated light itself as a palpable substance, not as ethereal or ephemeral matter but as an object with material form. It is, after all, in the very nature of the medium that any representation should partake of the same degree of actuality through the simple fact that it is composed of paint. It is not light that the artist paints, but pools of colour, not flowers, but a sequence of marks transcribed from a photograph. This embodiment of metaphorical suggestion within factuality accounts also for the dramatic, even theatrical, air of the paintings, the inanimate objects picked out by spotlights as if acting out an obscure

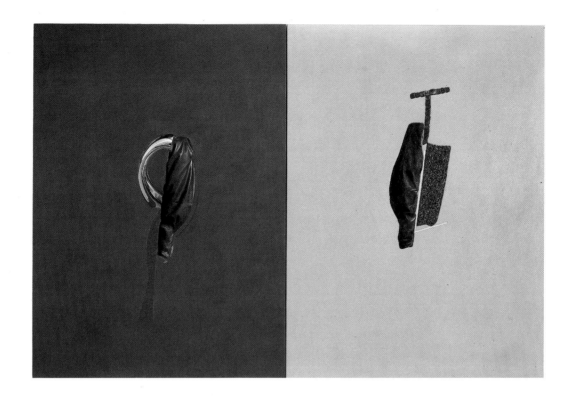

Gemini 1: Unvarying Mean *1981*
oil and wax on canvas (2 panels) 180 × 260
the artist *(cat. 46)*

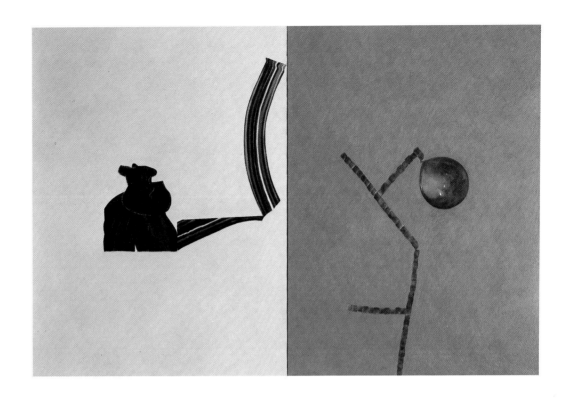

Gemini 3: The Unmoved Mover *1981*
oil on wax on canvas (2 panels) 180 × 260
Waddington Galleries, London *(cat. 48)*

performance for our benefit.

The second half of the 1970s was something of a crisis period for Phillips, although there is no doubt that he produced some memorable paintings during this time and introduced to his work new elements which continue to suggest further possibilities. The paintings which he began in the autumn of 1980 – *Road-runner,* followed by *The Pink One, Repetition of a Night-Time Safari, Aboriginal, Persistence of Desire,* and *Half the O in Vogue* – at first sight look startlingly different in form from the previous work, but closer examination reveals a number of ways in which standard preoccupations are perpetuated. The general effect of sparseness and the disposition of elements as scattered points of focus across the surface have much in common with works such as *No Focus Frames,* although the *trompe-l'oeil* depictions of complete objects have given way to illusionistic renderings of fragments of images. The spatial jumps which appeared to take place behind the surface in those paintings through the modelling of the image against painted shadows are treated in the new works as a physical reality in *front* of the surface, with sculptural elements made of plastic wood appended to the canvas so as to produce actual shadows. The use of relief elements, it will be recalled, occurred in Phillips's work as early as 1961, with the wooden panels of paintings such as *War/Game* and *For Men Only – Starring MM and BB,* and cast shadows had first appeared in *Philip Morris* 1962, providing further evidence of the consistency of the artist's logic over the years.[47]

The hypnotic intensity with which images such as the snakes in the *Mediator* pictures had been painted, crucial to the fascination exerted by these works, had a major practical disadvantage: it took too long. Phillips complained at the end of 1979 that he found it difficult to sustain the same degree of concentration over a period of two or three months in order to produce a single image. 'If I'm working intensely on an area and I'm making an image and concentrating on the colours, on texture and on the quality of the paint', he explained, by the time he had finished with this one element he had 'lost interest in the painting' as far as other aspects of it were concerned.[33] Phillips, of course, also had increasing reservations about

the use of images which might be construed as overtly symbolic. In the new paintings Phillips found that he could achieve a similar intensity of effect in a shorter period and without the symbolic obtrusiveness by employing the same fineness of technique to fragments of similar images; a snake skin and zebra skin figure, for example, in *Repetition of a Night-Time Safari,* although their main function now is as tactile and emotionally enigmatic images.

The concern with a heavily worked surface incorporating changes of pace, a central feature of the spotlight paintings such as *Flowers and Chain* 1978, is carried in the new works to extremes of unassuming virtuosity. Admitting to 'a semi-anarchistic point of view', Phillips deliberately 'mixed a lot of things together that aren't supposed to mix, acrylic and oil paint together with wax, in other words water-based and oil-based paints', with modelling paste to slow down the drying time of the acrylic and an emulsifier to fuse together the diverse elements.[1] Different techniques are also used for separate areas. Certain elements are painted with straight oil paint with medium, while others include graphite for a shiny surface or modelling paste to create a more solid substance. The background is coated with a *sfumato* layer mixed with wax, hardening and thus making more visible the controlled gestures of the brush. The surface is sometimes built up with additional pieces of canvas or with three-dimensional elements modelled in Plastiform plastic wood, with the result that it is difficult to tell from a distance which elements are physically real and which are painted illusions on the surface. In more recent paintings in the series such as *Sentinel* 1981 and *DUAL performance* 1981/82 the canvas is cut into or built out even further. All these contrasts are means of enticing the viewer into scrutinizing the surface, just as they had been in the paintings produced prior to the artist's adoption of the airbrush in 1964, in which similar contrasts were orchestrated between glossy and matt surfaces, collaged and imprinted areas, polished wood and pumiced canvas, gestural marks and anonymous surface.

The new paintings, enriched by twenty years' experience, can be said to have brought Phillips full circle. In view of the appeal which the collage principle has always held for him, it

Mosaik Stack No. 1 *1979*

Mosaikbild Stack No. 2 *1980*

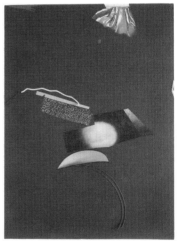

Persistence of Desire *1980*

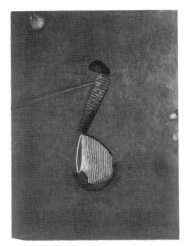

Sentinel 2 *1981*

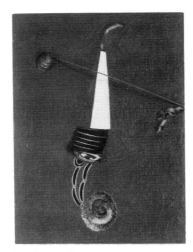

Roadrunner II *1981/82*

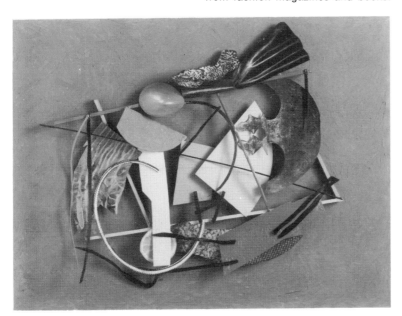

Relief Study No. 1 *1981*

should come as no surprise that their drastic revision of form was initially developed in a series of collages made in 1979–80, and that each canvas originated as a transcription of a particular work on paper. As always the images have been found ready-made, this time taken primarily from fashion magazines and books.

Rather than accepting the material exactly as he found it, however, Phillips overpainted the coloured backgrounds as well as the printed elements of the collages so as to intensify their physical presence while making their identity more mysterious and compelling.

The source material, though altered, infiltrates the paintings in an intriguingly oblique way. Clues are provided by some of the more recognizable images such as fabrics,

sequins and animal skins, even the method of presentation recalling fashion photography in which figures are posed against coloured backdrops. In the *Gemini* diptychs, in particular, the armature by which the various fragments are connected bears a strong suggestion of human presence, the individual elements and precise choice of colour attributing a specific personality to each panel. The associations, however, are never made explicit, so that the paintings of necessity remain open-ended and perplexing. The shock of recognition which one is led to experience through the sudden intrusion of a highly-defined passage – a familiar texture, a half-known object, a dim recollection of a specific visual sensation – is like the irrational certainty that one encounters in dreams, a felling of *déjà vu* for which there is no ultimate explanation.

'Now I think I've broken down the image barrier where I'm free to work more', commented the artist earlier this year. 'Maybe I can start to invent other images, using ready-mades, which these are starting to do.' He is still in the process of familiarizing himself with the new idiom, but he envisages countless ways of diversifying and recomplicating the basic principles, bringing in other kinds of illusion. 'I haven't got to the stage yet of colour gradations but it is going to come again. I was only at the moment trying to find a way to apply the paint. I have to become more familiar with it. I would like eventually a painted surface with perhaps lights in it, but I have to learn how to do it properly. When you want to have a sort of Rembrandt background, you've got to learn it, it takes time. So the support background becomes curved, varied, you play with light on it as they do on television behind announcers. In advertising this is a standard method of presentation, nevertheless it's fascinating, and you can rupture the space, you can build on it, and it satisfies my various whims. I haven't got 'round to going any further with it at the moment, because I haven't worked all *this* out.'

Released from the self-imposed limitations of his earlier work, Phillips feels regenerated and can begin to appreciate once more the possibilities inherent even to aspects of his paintings which he had regarded as false starts. 'I've always wanted to keep all the things that I've

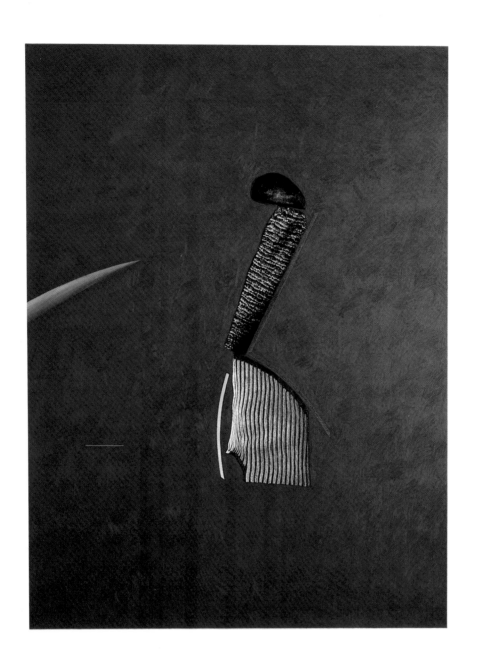

Sentinel *1981*
modelling paste, acrylic, oil and wax on canvas 214 × 160
Galerie Ziegler, Zürich *(cat. 49)*

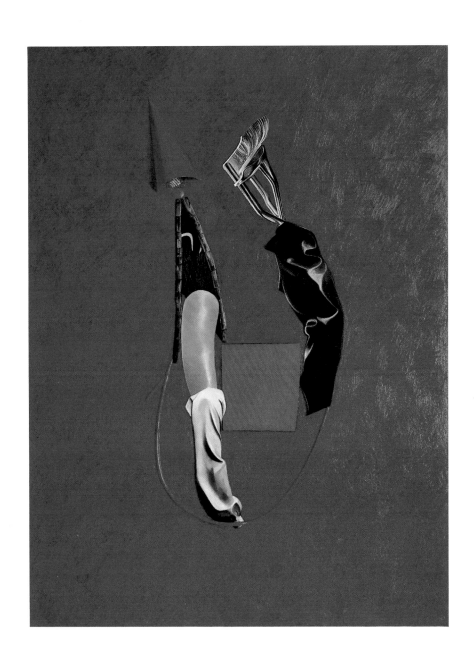

DUAL performance *1981/82*
modelling paste, acrylic, oil and wax on canvas 214 × 160
the artist *(cat. 51)*

been doing, but I don't want it to be stuck with that image that I had. Now I think I've found it and at least for a few years I can carry on consistently, because it's open enough and has everything that personally satisfies me in terms of working. It has a great range of flexibility within it that satisfies my particular whim at a particular time, from very small pieces up to the very large pieces and the different nature of work within it. And if I vary it occasionally when I want to freak out with something more complex, It also works.'[1]

Entanglement Series: Perpetual Flux 1981/82, the first of a possible series of large reliefs for which Phillips has already produced five painted cardboard maquettes, is the most complex work yet in the new idiom, both in terms of structure and imagery. An intricately-built assemblage of separate pieces of plywood (each covered with canvas on both sides and heat-pressed) dowelled together, disassembled, painted, and then reassembled, it bears a superficial resemblance to the painted aluminium reliefs made by Frank Stella in the late seventies. Although Phillips was aware of Stella's work, he had no intention of imitating it, just as he was not concerned in the previous paintings with allying himself with the New Image artists. Phillips's relief, like Stella's, consists of interpenetrating planes which come out at angles from the surface, the forms based on found images and painted. Where Stella, however, has used standard forms such as french curves which have been enlarged and then decorated with freely-brushed paint, Phillips has made a series of two-dimensional replicas of three-dimensional things which he has then reintegrated into a three-dimensional object. The process is quite a different one, and has roots in Phillips's own work at least as far back as *MULTImotor- PLICATION* 1963, with its irregularly-shaped and painted wooden panel.

Phillips at first considered suspending the interlocking armature of his relief straight on the wall, but eventually decided to attach it to a wooden surface that was covered with canvas and then painted, thus providing both a solid support for the construction and a coloured atmosphere in which to enclose the images. The solution thus harks back to the wall-hung reliefs made by Phillips in 1965, while maintaining an intimate relationship

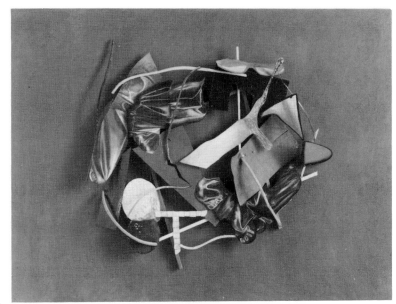

Relief Study No. 2 *1981*

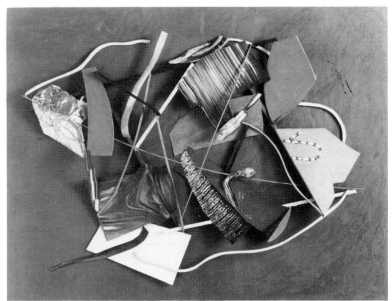

Relief Study No. 3 *1981*

with the current paintings in terms of image content and technique. To the animal skins and fabrics the artist now adds a new range of motifs, including a cocktail glass, skis, fragments of a Honda and an umbrella, some of these recognizable, others strangely alluring but unidentified.

Perpetual Flux is an apt subtitle for one of the recent works in this exhibition spanning more than two decades. It reflects not only the formal and emotional dynamism of Phillips's art but the means by which long-established concerns are constantly revitalized and reintegrated with new ideas, techniques and materials. Like a juggler who dares to

Relief Study No. 4 *1981*

Study for Gefährliches Spiel *1982*

Study for Gefährliches Spiel 2 *1982*

Study for Gefährliches Spiel 5 *1982*

keep an ever-growing number of increasingly complicated objects in the air, delighting the audience with his courage and ingenuity, so Phillips has continued to develop the elements of his art into a more and more dazzling display of his restless energy and imagination.

It might be thought that in changing the nature of his imagery and in bringing back obvious brushwork into his pictures, Phillips has entered a new phase of work which contradicts that which has gone before. One suspects, however, that the artist's playful irony is once again in operation and that all he has done is to lay a new trap for us, all the more successful for its unexpectedness. The deliberation with which Phillips has drawn attention to his rigidly-controlled brushwork should make it abundantly clear that he has not turned into an expressionist overnight, but that he is making use for his own ends of the current vogue for 'passionate' brushwork, knowing full well that it can be a useful ploy for engaging the viewer's attention. Phillips wears his insincerity on his sleeve. What could be more honest? If the artist is prepared to risk being misconstrued, it is only to enable us to enter into the spirit of his latest and most elaborate games. The series of paintings on which he is engaged at the time of writing, each of which incoporates illusionistic elements in relief, is not by accident named *Gefährliches Spiel:* 'dangerous game'. Willing as ever to take chances, Phillips continues to share with his audience the sheer pleasure of the creative act.

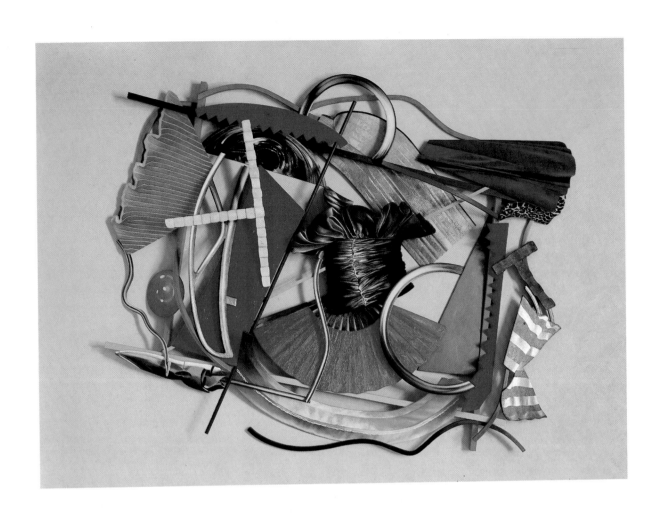

Entanglement Series: Perpetual Flux *1981/82*
oil, acrylic and wax on canvas and wood 200 × 271 × 25
the artist *(cat. 50)*

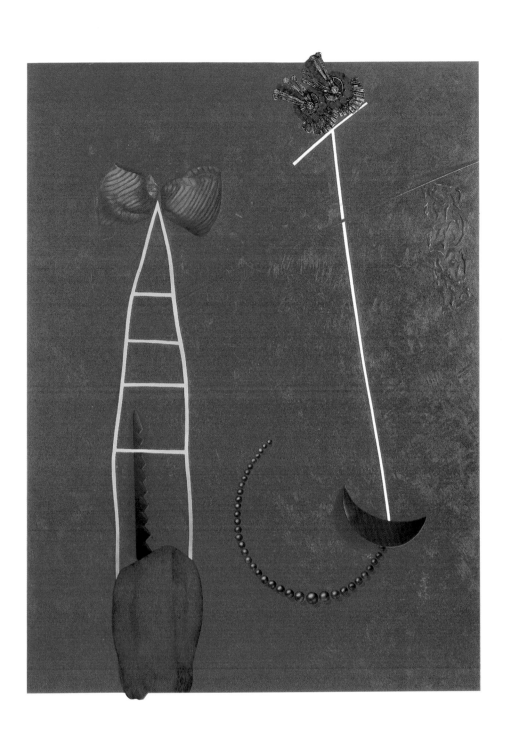

GEfährLICHES spiel: Praise/Insult *1982*
acrylic, oil and epoxy on wood and canvas 242 × 175 × 16 (overall)
the artist *(cat. 52)*

NOTES

1 Taped interview with the author, Zürich, 2 February 1982.

2 Taped interview with the author, London, 4 March 1976.

3 Exhibited *Young Contemporaries 1958*, RBA Galleries, London, 19 February - 10 March 1958, cat. nos. 125 & 247.

4 Taped interview with the author, Zürich, 2 February 1982. Phillips has consistently spoken of the relationship between his methods of pictorial construction and those of early Italian painting. In his statement in the catalogue for *The New Generation: 1964*, Whitechapel Gallery, London, March - May 1964, p. 72, Phillips wrote: 'In pre-Renaissance painting you get a complex visual situation with a central image, and other things related to the central image - but they are also a story or a presence in themselves. My attitude to painting hasn't been motivated by this, but it's something you can tie it to. I look on what I am trying to do now as a multi-assemblage of ideas inside one format, and I'm not restricted by one type of space, or by anything else. The different parts are arbitrary to each other but related because of the format.'

5 *The New American Painting*, Tate Gallery, London, 24 February - 22 March 1959.

6 E.g. in the exhibition *Place*, Institute of Contemporary Arts, London, October 1959, which featured paintings by Robyn Denny, Ralph Rumney and Richard Smith; *Situation: An Exhibition of British Abstract Painting*, RBA Galleries, London, September 1960, which included work by Bernard and Harold Cohen, Gillian Ayres, Robyn Denny and John Hoyland; and *New London Situation*, New London Gallery, London, August - September 1961, which again showed the Cohens, Hoyland and Smith among others.

7 *Big Orange* c. 1959 (oil on canvas, 145 x 157cm.) is in the collection of James Kirkman. Other paintings of this type were sold through the Savage Gallery, London, as set decorations to BBC Television; these paintings are now presumed destroyed.

8 Much of de Kooning's early work, with which *Bingo* bears comparison, was available in the form of reproductions in Thomas B. Hess, *Willem de Kooning* (George Braziller, New York, 1959), e.g. *Elegy* c. 1945 and *Pink Angels* c. 1945, plates 45 and 60 respectively.

9 Johns's *Large Target with Plaster Casts* 1955 was illustrated in colour in John Bernard Myers, 'The Impact of Surrealism on the New York School', in the *Evergreen Review*, March - April 1960, a copy of which was owned by Allen Jones and is still in his possession. Also reproduced in colour in the same article was Rauschenberg's 1959 combine-painting *The Eagle* and Larry Rivers's *The Next to Last Confederate Soldier* 1959, the imagery of which might have suggested the subject matter of Phillips's own *War/Game* 1961. The first painting by Johns to be exhibited in Britain was *White Numbers* 1957 in the exhibition *The Mysterious Sign*, Institute of Contemporary Arts, London, 26 October - 3 December 1960; his *Zero through Nine* 1961 entered the collection of the Tate Gallery in 1961. It was not until 1963, however, that the works of Johns, Rauschenberg or any of the new American Pop artists were seen again in this country, in the *Popular Image* exhibition, Institute of Contemporary Arts, London, 24 October - 23 November 1963. Johns and Rauschenberg were each the subject of a large-scale retrospective at the Whitechapel Gallery, London, in 1964.

10 See, for example, the review of Johns's first one-man show at the Castelli Gallery, New York, in *Art News*, January 1958; reproduced on the cover was *Target with Four Faces* 1955.

11 Quoted in *Image in Progress*, Grabowski Gallery, London, 15 August - 8 September 1962.

12 Phillips's transcription of the Goya painting (1814, Prado, Madrid) was painted c. 1961 from a photographic reproduction. It still survives and is now in a private collection.

13 Derek Boshier recalls (taped interview with the author, 8 March 1976) that Phillips was indignant when he incorporated a star badge in his 1961 construction *The Sheriff*, claiming the motif as his personal sign. The image was not borrowed by Phillips from the work of American Pop artist Robert Indiana, who was not known even in the United States until he had his first one-man show there in 1962. There is no direct connection between the work of the two artists;

Phillips recalls that Indiana called at his studio within two weeks of his arrival in New York in the autumn of 1964, but says that they did not establish further contact. The American Pop artist with whom Phillips has closest affinities is James Rosenquist, examples of whose work he had seen in reproduction before moving to New York. Rosenquist's first one-man exhibition, which included the ten by eighty-six foot painting *F-111* 1965, took place at the Castelli Gallery, New York, in April 1965 and was seen by Phillips, who was on nodding terms with the artist by that time.

14 *Young Contemporaries 1961*, Royal College of Art, London, 8 - 25 February 1961. Included were four works each by Phillips, Hockney, Jones and Kitaj, three by Boshier and two by Caulfield.

15 Allen Jones, taped interview with the author 15 March 1976.

16 In a letter to Christopher Taylor dated 'Friday', c. late 1961, Phillips outlined 'two short movies' on which he was working: 'one is about a duel in the underground, with all the sick faces there; and one I'm doing on my own, about the twist (that dance craze) . . .' Phillips later recalled of these films that he just 'went through the motions . . . I took no interest. I didn't finish them. I worked with some other guy, he was incredibly enthusiastic, but I never got very interested in making films or even taking photographs.' (Taped interview with the author, London, 4 March 1976).

17 Several exhibitions of Blake's work took place in London in 1960: *Theo Crosby Sculpture/Peter Blake Objects/John Latham Libraries*, Institute of Contemporary Arts, January 1960, which featured mainly works of 1959, doors and collaged paintings with photographs and postcards, such as *The Fine Art Bit*, *The Everly Wall*, *Elvis and Cliff*, *Sinatra Door* and *Girlie Door*; *Peter Blake and Tony Gifford: Grass and Gold*, New Vision Centre, 18 January - 6 February 1960, in which Blake's contribution was limited to 'gold pictures representing sections of Japanese screens', an exhibition which Phillips does recall having seen; and *Peter Blake/Ivor Abrahams Objects/Roddy Maude-Roxby*, Portal Gallery, 7 March - 2 April 1960, which featured Blake's figure paintings of the 1950s such as *Drum Majorette* 1957, *ABC Minors* 1955 and *Sammy Davis Jr.* 1957-60. Phillips certainly knew Blake and his work by the time of the opening of the *John Moores Liverpool Exhibition* in mid-November 1961, for in an undated letter to Christopher Taylor written shortly after this occasion he commented: 'I went up to Liverpool . . . to see the exhibition; our little group here in London looked by far the best work there, though I'm not just patting myself on the back. Peter Blake's painting [*Self-Portrait with Badges* 1961] looked great and deserved the prize; but don't be fooled by any crap they shoot at the Portal; Peter has enough work for two one-man shows, at least.' Blake and Phillips were filmed together with Boshier and Pauline Boty in February 1962 for the BBC Monitor film 'Pop Goes the Easel', directed by Ken Russell and broadcast on 25 March 1962.

18 *This is Tomorrow* was held at the Whitechapel Gallery, London, August - September 1956. Of the twelve environments in this exhibition, only that devised by Hamilton with John McHale and John Voelcker was overtly concerned with popular art. Phillips does not recall seeing Hamilton's work in the early '60s. 'He wasn't around in London from what I can remember, I didn't even know him. I had vaguely heard of him. *This is Tomorrow* - I didn't even know it existed.' (Tape interview with the author, London, 4 March 1976).

19 Independent Group ideas had, however, infiltrated the Royal College student magazine *Ark* in the preceding decade, in articles such as 'But Today We Collect Ads' by Alison and Peter Smithson, *Ark 18*, November 1956, p. 49-50; 'Technology and Sex in Science Fiction' by Lawrence Alloway, *Ark 17*, summer 1956, p. 19-23; and a special issue devoted to 'aspects of the popular arts' in the spring of 1957 (*Ark 19*), which included Alloway's 'Personal Statement', in which he emphasized the importance of the mass media in overcoming 'the lingering prestige of aestheticism and fine art snobbism', along with Roger Coleman's 'Dream Worlds, assorted' and the second of two articles on Hollywood movies by the painter Richard Smith. Comics were another persistent subject of study in the pages of *Ark* as early as spring 1954 with an article by then-editor Rosalind Dease and Len Deighton, 'Funnies Ha Ha?', *Ark 10*, p. 52-58; Peter Blake

contributed two comic strips to the magazine, in *Ark 24*, autumn 1959, and *Ark 25*, spring 1960.

20 Quoted in 'Three British Artists in New York', *Studio International*, November 1965, p. 183.

21 Robert L. Delevoy, *Léger* (Skira, 1962).

22 Fernand Léger, *Functions of Painting* (Thames and Hudson, London, 1973), republishes among other essays 'The Machine Aesthetic: The Manufactured Object, the Artisan and the Artist' (1924) and 'The Machine Aesthetic: Geometric Order and Truth' (1925), p. 52-66.

23 Quoted in Katharine Kuh, *Léger* (The University of Illinois Press, Urbana, 1953), p. 44 and 33.

24 As in the case of Léger, little of the work of these artists could be studied in England at first hand. A Schwitters exhibition was shown at the Arts Council Gallery, Cambridge, 14 November - 5 December 1959. A Picabia retrospective was held in April 1964 at the Institute of Contemporary Arts, London.

25 Phillips now owns a 1969 edition of *Vision in Motion* (Paul Theobald and Company, Chicago) but says that this was a replacements of an earlier edition, which he had lost.

26 Compare, for example, Blake's *The Fine Art Bit* 1959 (coll. Tate Gallery) or *Got a Girl* 1960/61 (coll. Whitworth Art Gallery, University of Manchester). The racing car and galleon stencils used by Phillips in *Racer* and *We Three Ships*, each design measuring approximately six inches in width, were from Reeves stencil packet no. 22, a set of which was still owned by Derek Boshier as late as March 1976, although there is no evidence that Boshier himself ever used them.

27 The automobile first appeared in Phillips's work in *Car Space* (oil on canvas and wood with inset panels, 182.5 × 187cm., coll. the artist), a shaped canvas begun in 1963 but never completed. Although *AutoKUSTOMotive* was not preceded by any direct compositional studies, drawings with related imagery were produced by Phillips during 1963/64. See Enrico Crispolti, *Peter Phillips* (Idea e, London, 1977), plates 100, 102, 103, 107.

28 See *Richard Smith: Seven Exhibitions 1961-75*, Tate Gallery, London, 13 August - 28 September 1975, cat. nos. 18 and 14. These works were first exhibited in a one-man show at the Kasmin Gallery, London, November - December 1963.

29 Quoted in Mario Amaya, *Pop as Art: A Survey of the New Super-Realism* (Studio Vista, London, 1965), p. 132.

30 Quoted in Kuh, *Léger, op. cit.*, p. 35.

31 See, for example, Léger's *Two Plungers* 1944 and *Divers on Yellow Background* 1941, reproduced in Kuh, *op. cit.*, p. 54 and 55. *Select-O-Mat Rear Axle* is reproduced in Crispolti, *op. cit.*, plate 60.

32 Gerald Laing, undated letter to the author, February 1982.

33 Taped interview with the author, London, 19 October 1979.

34 G. R. Swenson, 'Hybrid: a time of life', *Art and Artists*, June 1966, p. 62-65.

35 In conversation with the author, London, 18 September 1979.

36 As early as 1967 Edward Lucie-Smith noted that Phillips's 'departure for America has left a gap in the Pop scene which hasn't quite been filled by anyone else. His recent work has been so little shown in England that . . . it's almost as if he had been cut off in mid-career. His influence certainly vanished very rapidly from the British scene once he departed.' See 'What Ever Happened to British Pop?', *Art and Artists*, May 1967, p. 16-19.

37 Unpublished interview with Pat Gilmour, London, 5 November 1975. The transcript is in the Tate Gallery Archives.

38 Since that time Winsor & Newton have introduced Liquin, and a colour factory in Zürich, prodded in part by Phillips himself, has developed an acrylic paint suitable for the airbrush. By the time that was available, however, Phillips had decided to give up the instrument. Phillips, incidentally, had first tried acrylic in small areas of *Kewpie Doll* 1963/64, but abandoned it thereafter and did not use it again until 1968.

39 See the entry on *Random Illusion No. 4* in *The Tate Gallery 1968-70* (Tate Gallery, London, 1970), p. 98, for full details of the painting's source material.

40 All the birds in the *Random Illusion* series were based on illustrations in a single edition of John James Audubon, *The Birds of America* (McMillan, New York, 1965), a volume still owned by the artist. The pair of rough-legged hawks used in *No. 1* and *No. 6* are both from plate 422 in the Audubon book; in the first instance the spatial relationship between the two birds is retained, but the entire image is reversed, while in the later painting the image is not reversed but the birds are represented at a much greater distance from each other than they were in the source. The young bald eagle represented in *No. 2* is from plate 126, while the rough-legged hawk in *No. 3* and *No. 5*, in each case reversed, is from plate 166. The pair of red-shouldered hawks in *No. 4*, taken from plate 56, are pictured the same way around as in the illustration although the lower of the two birds has been moved further to the right for the sake of compositional balance.

41 The wood ducks in *Select-O-Mat Techtotempest* and turkey vulture in *Front Axle* are taken from the paintings by J. Fenwick Lansdowne in John A. Livingston, *Birds of the Eastern Forest: 1* (Paul Hamlyn, London, 1968), plates 8 and 9. The same book supplied the pileated woodpeckers which feature in *Converter* 1973 (reproduced in Crispolti, *op. cit.*, plate 80) and the yellow-billed cuckoo of *Art-O-Matic Blue Moon* 1973, plates 40 and 29 respectively. The pneumatic nude in *Select-O-Mat Rear Axle* was taken from the pages of *Playboy*, the blonde in *Art-O-Matic Cudacutie* from an illustration by Petty, and the acrobatic figure in *Art-O-Matic Loop di Loop*, which reappears in *Art-O-Matic Riding High* 1973/74, from Vargas's famous 1944 calendar (February).

42 One of the first major surveys of the new movement, *Photo-Realism: Paintings, sculpture and prints from the Ludwig Collection and others*, took place at the Serpentine Gallery, London, 4 April - 6 May 1973. The painters taking part were Robert Bechtle, Chuck Close, Robert Cottingham, Don Eddy, Richard Estes, Ralph Goings, Howard Kanovitz, Richard McLean, Malcolm Morley and John Salt.

43 An awareness of the same mechanism might account for the change of form which took place in the photo-pieces of Gilbert and George in 1974 from irregular configurations to a uniform rectilinear grid. See *Gilbert and George 1968 to 1980*, Municipal Van Abbemuseum, Eindhoven, 1980.

44 The Kunsthartz (artificial resin-based) paint made by the Dutch firm Rembrandt, which had given Phillips such satisfactory results in *La Doré* and *Supergirl*, was not used again because the artist found it too 'poisonous' for spraying. By 1975 Phillips had discovered that there was a way of laminating colour photographs onto canvas so that they would be as permanent as paintings. He says that he would have no objections to the image being produced in such a mechanical way, but that the problem of piecing together separate photographs - dictated by the paper sizes that are commercially available - and the expense of working with colour photography on such a scale ruled it out. Similarly it is only practical considerations which stop Phillips from using even more sophisticated technology. 'I've got no snobbism about this sort of thing. I have booklets about all the latest computers, which I would use if they were easily programmable. But at the moment it's still a little complicated with the language, understanding how to do a programme. But I would certainly use it to manipulate everything, to get a million results in one day instead of just a few.' (Taped interview with the artist, Zürich, 2 February 1982).

45 In conversation with the author, London, 18 September 1979. Richard Hamilton had also become interested in flowers as 'a sentimental cliché' in his paintings and prints of the early seventies, but from an iconographic rather than psychological or emotional point of view as in Phillips's case. See *Hamilton: Paintings, pastels, prints*, Serpentine Gallery, London, 4 October - 2 November 1975.

46 J. E. Cirlot, *A Dictionary of Symbols* (Routledge & Kegan Paul, London, 1962), p. 272-277. In addition to this entry on the serpent, this same volume analyses the symbolism of a number of other images which Phillips has used intuitively over the years, such as the lion, the tiger, the hawk, the eagle, and the lily.

47 It is evident, too, that Phillips was looking again at early Italian painting, in which the physical presence of an image - for example, the halo around a saint - is reinforced by building up the surface in gesso and then colouring it.

CHRONOLOGY

1939:
born Birmingham 21 May
1953-55:
Moseley Road Secondary School of
Art, Birmingham
1955-59:
Birmingham College of Art: 2 years
Intermediate and 2 years N.D.D.
(special level course); studied under
Gilbert Mason and Fleetwood-Walker
1959:
summer trip to Paris and to Italy on a
scholarship awarded by Birmingham
College of Art
1959-62:
Royal College of Art: fellow students
included David Hockney, R. B. Kitaj,
Allen Jones, Derek Boshier and
Patrick Caulfield; transferred from
Painting School to Television School
in the autumn of 1961 but was
granted his Diploma in Painting in
June 1962
1962-63:
taught at Coventry College of Art and
Birmingham College of Art
1964:
designed entrance hall and large
machine for Shakespeare exhibition,
Stratford-upon-Avon
awarded a Harkness Fellowship for
travel to the United States
1964-66:
lived in New York City, travelled
around North America by car with
Allen Jones in 1965
1965-66:
formed Hybrid Enterprises with
Gerald Laing
1966:
returned to Europe
1968-69:
Guest Professor, Hochschule für
Bildende Künste, Hamburg
1970:
married Marion-Claude Xylander
frequent trips throughout the 1970s
to Africa, the Far East, and the
United States
1972:
retrospective exhibition at the
Westfälischer Kunstverein, Münster
1976:
first one-man show of paintings in
England held at the Waddington
Galleries, London
1981:
visit to Australia
1982-83:
retrospective exhibition at the Walker
Art Gallery, Liverpool, travelling to
the Museum of Modern Art, Oxford;
the Laing Art Gallery, Newcastle-
upon-Tyne; the Fruit Market Gallery,
Edinburgh; Southampton Art Gallery;
and Barbican Art Gallery, London
lives in Zürich

ONE-MAN EXHIBITIONS

1965
•Kornblee Gallery, New York
1966
•Kornblee Gallery, New York ('Hybrid'
 with Gerald Laing)
1967
•Galerie Bischofberger, Zürich
1968
•Galerie der Spiegel, Cologne
•Galerie Bischofberger, Zürich
•Kornblee Gallery, New York
•Galleria del Leone, Venice
•Alecto Gallery, London (prints)
1969
•Galerie Bischofberger, Zürich
•Studio d'arte Condotti, Rome
1970
•Galleria Milano, Milan
1971
•Galerie Dorothea Leonhart, Munich
•Galleria d'arte Vinciana, Milan
•Studio d'arte Condotti, Rome
1972
•Westfälischer Kunstverein, Münster
 (retrospective)
1974
•Galerie Bischofberger, Zürich
•Galleria Plura, Milan
1975
•Galleria l'Impronta, Naples
•Galleria la Chiocciola, Padua
1976
•Tate Gallery, London (prints)
•Waddington Galleries, London
1982
•Galerie Ziegler, Zürich
1982-83
•Walker Art Gallery, Liverpool
•Museum of Modern Art, Oxford
•Laing Art Gallery, Newcastle-upon-Tyne
•Fruit Market Gallery, Edinburgh
•Southampton Art Gallery
•Barbican Art Gallery, London

Peter Phillips in his studio, London, *1963*
(photograph © J. S. Lewinski)

GROUP EXHIBITIONS

1958
• 'Young Contemporaries', RBA Galleries, London
1960
• 'Young Contemporaries', RBA Galleries, London
1961
• 'Young Contemporaries', RBA Galleries, London
• 'John Moores Liverpool Exhibition 3', Walker Art Gallery, Liverpool
1962
• 'Young Contemporaries', RBA Galleries, London
• 'British Painting and Sculpture Today and Yesterday', Arthur Tooth & Sons, London
• 'British Painting', American Embassy, London
• 'Four Young Artists', Institute of Contemporary Arts, London
• 'Image in Progress', Grabowski Gallery, London
• 'International Exhibition of the New Realists', Sidney Janis Gallery, New York
• '"Towards Art?" An Exhibition showing the contribution which the College has made to the Fine Arts 1952-62', Royal College of Art, London
• 'British Art Today', San Franscisco Museum of Art
1963
• 'British Art Today', Dallas Museum of Contemporary Art and Santa Barbara Museum of Art
• '1962: One Year of British Art selected by Edward Lucie-Smith', Arthur Tooth & Sons, London
• 'Towards Art?', Arts Council of Great Britain touring exhibition
• 'Pop Art', Midland Group, Nottingham
• 'British Painting in the Sixties', Whitechapel Art Gallery, London
• 'Troisième Biennale des Jeunes', Musée d'Art Moderne de la Ville de Paris
1964
• 'British Paintings from the Paris Biennale 1963', Royal College of Art, London
• 'Colour, Form and Texture', Arthur Tooth & Sons, London
• 'The New Generation: 1964', Whitechapel Gallery, London
• 'Britische Malerei der Gegenwart', Kunstverein für die Rheinlande und Westfalen, travelling to Bochum, Munich and Zürich
• 'The New Image', Arts Council Gallery, Belfast
• 'Pop etc.', Museum des 20. Jahrhunderts, Vienna
• 'Contemporary British Painting and Sculpture', Albright-Knox Art Gallery, Buffalo
• 'Pick of the Pops', National Museum of Wales, Cardiff
• 'Nieuwe Realisten', Gemeentemuseum, the Hague
• 'Premio Marzotto', touring exhibition, Rome, Baden-Baden, Berlin, Amsterdam, Paris and London
• 'Rule Britannia', Feigen/Palmer Gallery, Los Angeles
• 'Figuratie/Defiguratie De Menselijke Figur Sedert Picasso', Museum voor Schone Kunsten, Ghent
• 'Neue Realisten & Pop Art', Akademie der Künste, Berlin
1965
• 'Pop Art, Nouveau Réalisme etc.', Palais des Beaux-Arts, Brussels
• 'Jeune peinture anglaise: Pop-Art, op-art et autres tendances', Galerie Motte, Geneva
• 'La Figuration narrative dans l'art contemporain', Galerie Creuze, Paris
• 'Op and Pop', Moderna Museet, Stockholm
• 'Peter Stuyvesant - A Collection in the Making', Whitechapel Gallery, London
• 'ICA Prints', Institute of Contemporary Arts, London
1966
• '11 Pop Artists: the New Image', Galerie Friedrich & Dahlem, Munich
• 'Primary Structures', Jewish Museum, New York
• 'Recent Paintings, Drawings and Sculpture 1958-1966 by the Harkness Fellows', the Leicester Galleries, London
• 'The Other Tradition', Institute of Contemporary Art, University of Pennsylvania, Philadelphia
• 'British Painting', Palais des Beaux-Arts, Brussels
• 'Artists for Core', Grippi and Waddell Gallery, New York
• 'A New Look in Prints', Museum of Modern Art, New York
• 'Irish Exhibition of Living Art 1966', Gallery of the National College of Art, Dublin
• Galerie M. E. Thelen, Essen
• Galerie Neuendorf, Hamburg
• Galerie Bischofberger, Zürich
• 'Pop and Op', an exhibition circulated by the American Federation of Arts
1967
• 'Englische Kunst', Galerie Bischofberger, Zürich
• 'Pop Prints', Arts Council of Great Britain
• 'Homage to Marilyn Monroe', Sidney Janis Gallery, New York
• 'Le visage de l'homme dans l'art contemporain', Musée Rath, Geneva
• 'Junge Englische Kunst', Kunsthalle Bern
• 'British Drawings: The New Generation', an exhibition circulated by the Museum of Modern Art, New York
• 'Contemporary British Painting', the Wilmington Society of the Fine Arts, Wilmington, Delaware
• 'Jeunes Peintres Anglais', Palais des Beaux-Arts, Brussels
• Galleria de Foscherari, Bologna
• 'Recent British Painting - Peter Stuyvesant Foundation Collection', Tate Gallery, London
1968
• 'The Obsessive Image', Institute of Contemporary Arts, London
• 'The New Generation 1968: Interim', Whitechapel Gallery, London
• 'Junge Generation Grossbritannien', Akademie der Kunst, Berlin
• 'Painted in Britain: an exhibition originated by the Institute of Contemporary Arts, London', Macy's, New York

GROUP EXHIBITIONS
CONTINUED

•'Grabados de artistas británicos nuevas tendencias', Museo de Arte Moderno, Mexico City
•'Collagen', Kunstgewerbemuseum, Zürich
•'British Artists: 6 Painters, 6 Sculptors', an exhibition circulated by the Museum of Modern Art, New York
1969
•'Pop Art', Hayward Gallery, London
•'Information', Kunsthalle, Basel, and Badischer Kunstverein, Karlsruhe
•'Painting and Sculpture Today', Heron Museum of Art, Indianapolis, Indiana
1970
•'The Spirit of the Comics', Institute of Contemporary Art, University of Pennsylvania, Philadelphia
•'Dritte Internationale der Zeichnung', Darmstadt
•'L'Estampe en Suisse', Musée des Arts Décoratifs de la Ville de Lausanne
•'Internationale Triennale für farbige Druckgraphik', Grenchen
•Art Lending Service, Museum of Modern Art, New York
1971
•'Critic's Choice', Arthur Tooth & Sons, London
•'Around the Automobile', Hofstra University, Hempstead, New York
•'Accouragge', Galerie Bischofberger, Zürich
•Galerie Bischofberger, Basel Art Fair
1974
•'Graveurs anglais contemporains', Musée d'Art d'Histoire des Estampes, Geneva
•'British Painting '74', Hayward Gallery, London
1976
•'Pop Art in England: Beginnings of a new Figuration 1947-63', Kunstverein Hamburg, travelling to Lenbachhaus, Munich, and York City Art Gallery
•'Fifth British International Print Biennale', Cartwright Hall, Bradford
1977
•'1977 Hayward Annual', Hayward Gallery, London
•'British Painting 1952-1977', Royal Academy, London
•'Paris Biennale Anthologie 1959-67', Musée d'Art Moderne de la Ville de Paris
•'British Painting in the '60s', Tate Gallery, London
•'British Painting from the '60s', Dundee Museum and Art Gallery
•'Malerei und Photographie in Dialog', Kunsthaus, Zürich
•'International Biennial of Graphic Art', Yugoslavia
1979
•'Images of Ourselves', Tate Gallery, London
•'Sixth British International Print Biennale', Cartwright Hall, Bradford
•'British Drawings since 1945', Whitworth Art Gallery, Manchester
•'Photography in Printmaking', Victoria and Albert Museum, London
1980
•'Kelpra Studio: Artists' Prints 1961-1980', Tate Gallery, London
1981
•'Avantgarden Retrospektiv: Kunst nach 1945', Westfälischer Kunstverein, Münster

ILLUSTRATIONS TO THE TEXT

One Five Times/Sharp Shooter *1960*
oil on canvas (dimensions unknown)
private collection

Wall Machine *1961*
oil on canvas 180 × 150
private collection

Burlesque/Baby Throw *1961*
oil, metal hooks, wooden rings and collage on
canvas 180 × 150
private collection

Tribal 1 x 4 *1962*
oil on canvas 106.7 × 99
private collection

Motorpsycho/Club Tiger *1962*
oil on canvas with lacquered wood 127 × 76.6
private collection

Motorpsycho/Go *1962*
oil on canvas with lacquered wood 157 × 101.6
Tehran Museum of Contemporary Art

Philip Morris *1962*
oil on canvas with lacquered wood and collage
86.3 × 55
private collection

Racer *1962*
oil on board 36.8 × 22.2
private collection

Distributor *1962*
oil and collage on canvas with lacquered moving
panels 180 × 150
private collection

Four Stars *1963*
oil on canvas 210 × 150
private collection

SUPinsetER *1963*
oil on canvas with inset panels 182 × 122
private collection

INsuperSET *1963*
oil on canvas with inset panels 214 × 152.5
Calouste Gulbenkian Foundation, Lisbon

MULTImotorPLICATION *1963*
oil on canvas with painted wood relief 204 × 128
Neue Pinakothek, Munich

Custom Painting No. 4 *1964*
oil on canvas 214 × 175
Hessisches Landesmuseum, Darmstadt

Hybrid *1966*
co-production with Gerald Laing
polished aluminium, lacquered brass, plexiglass
and neon light 132 × 175; an edition was also
produced on a smaller scale
one of the two large pieces is now in the
collection of the Fogg Art Museum, Harvard

Tiger-Tiger *1968*
oil on canvas with coloured plexiglass 152 × 227
private collection

The Random Illusion No. 4 *1968*
acrylic and tempera on canvas with lacquered
wood 200 × 340
Trustees of the Tate Gallery

Christmas Eve *1968*
Screenprint 61.5 × 96 published by Edition
Bischofberger, Zürich, in an edition of 75

SUNgleam *1968*
Screenprint 61.5 × 96 published by Edition
Bischofberger, Zürich, in an edition of 75

Front Axle *1970*
oil, tempera and acrylic on canvas 250 × 510
destroyed by flood water 1971

Select-O-Mat Rear Axle *1971*
acrylic and tempera on canvas 250 × 510
Hans Looser

Love Birds *1974*
acrylic on canvas 175 × 125
the artist

Mosaikbild 6 x 12 *1974*
oil on canvas 160 × 320
Guarda Val

Mosaikbild 6 x 11 *1975*
acrylic on canvas 179 × 300
Ulster Museum, Belfast

Mosaikbild/Displacements *1976*
acrylic on 34 canvases in wooden grid 220 × 230
private collection

Classifications May Vary *1976/77*
oil on canvas with inset panel 180 × 90
Charles Grohe

Untitled *1976/77*
oil on canvas with inset panel 180 × 90
Charles Grohe

Rustic Ice Ray *1977*
oil on canvas 220 × 120
private collection

Greetings *1977*
oil on canvas with inset panel 180 × 90
private collection

Untitled *1978*
oil on canvas 110 × 220
private collection

Untitled *1978*
oil on canvas 110 × 220
private collection

Fibre Light *1979*
oil on canvas 100 × 100
the artist

Balls & Chain No. 1 *1979*
oil on two canvases 100 × 100
Durig collection

Mosaik Stack No. 1 *1979*
oil on paper
Guizetti collection

Mosaikbild Stack No. 2 *1980*
oil on paper 72 × 68
the artist

Persistence of Desire *1980*
modelling paste, acrylic, oil and wax on canvas
214 × 160
Dr. and Mrs. C. Krayenbühl

Sentinel 2 *1981*
oil, collage, wood and metal on paper 61 × 45
Dr. Shubiger

Roadrunner II *1981*
oil, wood and collage on paper 61 × 45
the artist

Relief Study No. 1 *1981*
oil on card and wood 45 × 61
Lindenmeyer collection

Relief Study No. 2 *1981*
oil on card and wood 45 × 61
the artist

Relief Study No. 3 *1981*
oil on card and wood 45 × 61
the artist

Relief Study No. 4 *1981*
oil on card and wood 45 × 61
Kitty and Paul Mirani

Study for Gefährliches Spiel *1982*
oil, wood and collage on paper 61 × 45
the artist

Study for Gefährliches Spiel 2 *1982*
oil, wood and collage on paper 61 × 45
the artist

Study for Gefährliches Spiel 5 *1982*
oil, wood and collage on paper 61 × 45
the artist

WORKS BY OTHER ARTISTS:

CIMABUE. **Madonna Enthroned with Angels and
Four Prophets** *c.1280/85*
tempera on wood 385 × 223
Galleria degli Uffizi, Florence

WASSILY KANDINSKY. **Composition IX** *1936*
oil on canvas 114 × 195
Musée National d'Art Moderne, Paris
(© A.D.A.G.P. Paris, 1982)

FERNAND LÉGER. **Contaste d'Objets** *1930*
oil on canvas
Musée National d'art Moderne, Paris
(© S.P.A.D.E.M. Paris, 1982)

All dimensions are given in centimetres,
height before width

LIST OF WORKS

1 **Bingo** *1960*
oil on canvas 177.4 × 145.3
private collection

2 **Purple Flag** *1960*
oil and wax on canvas 213 × 184
private collection

3 **War/Game** *1961*
oil and polished wood on canvas 210 × 150
Albright-Knox Art Gallery, Buffalo, New York, Gift of Seymour H. Knox, 1964

4 **For Men Only - Starring MM and BB** *1961*
oil and collage on canvas 274.5 × 152.5
Calouste Gulbenkian Foundation, Lisbon

5 **Motorpsycho/Tiger** *1961/62*
oil on canvas with lacquered wood 205.5 × 150.5
private collection

6 **Forever Corporation** *1962*
oil on canvas 244 × 152
private collection

7 **Spotlight** *1962/63*
oil on canvas with lacquered wood 238 × 157
Bruno Bischofberger Gallery, Zürich

8 **Gravy for the Navy** *1963*
oil on canvas with lacquered wood and glass 233.5 × 157.5
Oldham Art Gallery and Museum

9 **Kewpie Doll** *1963/64*
oil on canvas 132 × 107
private collection

10 **Custom Painting No. 2** *1964/65* (copy *1972*)
oil on canvas 214 × 175
private collection

11 **Custom Painting No. 5** *1965*
oil on canvas 175 × 300
Bruno Bischofberger Gallery, Zürich

12 **The Random Illusion No. 1** *1968*
acrylic on canvas with coloured plexiglass 200 × 340
Hans Looser

13 **The Random Illusion No. 2** *1968*
acrylic and tempera on canvas with coloured plexiglass 200 × 340
Waddington Galleries, London

14 **The Random Illusion No. 3** *1968*
acrylic and tempera on canvas with lacquered wood 200 × 340
Galerie Neuendorf, Hamburg

15 **The Random Illusion No. 6** *1968*
acrylic and tempera on canvas with lacquered wood 228 × 401
Galerie Neuendorf, Hamburg

16 **Select-O-Mat Techtotempest** *1971*
acrylic on canvas 250 × 510
Galerie Neuendorf, Hamburg

17 **Art-O-Matic Cudacutie** *1972*
acrylic on canvas 200 × 400
Waddington Galleries, London

18 **Art-O-Matic Loop di Loop** *1972*
acrylic on canvas 200 × 400
Galerie Neuendorf, Hamburg

19 **Composition No. 5** *1972*
acrylic on canvas 93 × 133.5
Galerie Neuendorf, Hamburg

20 **Composition No. 8** *1972*
acrylic on canvas 93 × 133.5
Waddington Galleries, London

21 **Composition No. 14** *1972*
acrylic on canvas 93 × 133.5
Galerie Neuendorf, Hamburg

22 **Composition No. 15** *1972*
acrylic on canvas 93 × 133.5
Waddington Galleries, London

23 **Composition No. 16** *1972*
acrylic on canvas 93 × 133.5
Galerie Neuendorf, Hamburg

24 **Select-O-Mat Variation No. 4** *1973*
acrylic on canvas 93 × 133.5
Galerie Neuendorf, Hamburg

25 **Select-O-Mat Variation No. 7** *1973*
acrylic on canvas 93 × 133.5
Waddington Galleries, London

26 **Select-O-Mat Variation No. 9** *1973*
acrylic on canvas 93 × 133.5
Galerie Neuendorf, Hamburg

27 **Select-O-Mat Variation No. 10** *1973*
acrylic on canvas 93 × 133.5
Galerie Neuendorf, Hamburg

28 **Automobilia** *1973*
acrylic on canvas (2 panels) 200 × 300
Walker Art Gallery, Liverpool (Merseyside County Council)

29 **Art-O-Matic Blue Moon** *1973*
acrylic and metallic jewels on canvas 200 × 150
Lindenmeyer collection

30 **Art-O-Matic Riding High** *1973/74*
acrylic on canvas 200 × 150
Claude Phillips

31 **Select-O-Mat Variation No. 13** *1974*
acrylic on aluminium 93 × 133.5
Waddington Galleries, London

32 **Select-O-Mat Variation No. 14** *1974*
acrylic on aluminium 93 × 133.5
Galerie Neuendorf, Hamburg

33 **Select-O-Mat Variation No. 16** *1974*
acrylic on canvas 93 × 133.5
Galerie Neuendorf, Hamburg

34 **Mosaikbild 5 x 4/La Doré** *1975*
oil on canvas 200 × 150
Lindenmeyer collection

35 **Mosaikbild 5 x 5/Supergirl** *1975*
oil on canvas 200 × 200
O. R. Triebold

36 **Solitaire is the Only Game in Town** *1976*
acrylic and oil on canvas 250 × 125
Galerie Neuendorf, Hamburg

37 **Carnival** *1977*
oil on canvas 220 × 120
the artist

38 **Flowers & Chain** *1978*
oil on canvas 100 × 100
private collection

39 **Mediator 1** *1979*
oil on canvas 135 × 220
Dr. R. Müller

40 **Mediator 2** *1979*
oil on canvas 180 × 180
private collection

41 **Roadrunner** *1980*
modelling paste, acrylic, oil and wax on canvas 214 × 160
Lindenmeyer collection

42 **The Pink One** *1980*
modelling paste, acrylic, oil and wax on canvas 214 × 160
Claude and Zoé Phillips

43 **Repetition of a Night-Time Safari** *1980*
modelling paste, acrylic, oil and wax on canvas 214 × 160
Waddington Galleries, London

44 **Aboriginal** *1980*
modelling paste, acrylic, oil and wax on canvas on wood 214 × 160
Galerie Ziegler, Zürich

45 **Half the O in Vogue** *1980/81*
modelling paste, acrylic, oil and wax on canvas 214 × 160
Dr. R. Müller

46 **Gemini 1: Unvarying Mean** *1981*
oil and wax on canvas (2 panels) 180 × 260
the artist

47 **Gemini 2: Purpose and Passiveness** *1981*
oil and wax on canvas (2 panels) 180 × 260
the artist

48 **Gemini 3: The Unmoved Mover** *1981*
oil and wax on canvas (2 panels) 180 × 260
Waddington Galleries, London

49 **Sentinel** *1981*
modelling paste, acrylic, oil and wax on canvas 214 × 160
Galerie Ziegler, Zürich

50 **Entanglement Series: Perpetual Flux** *1981/82*
oil, acrylic and wax on canvas and wood 200 × 271 × 25
the artist

51 **DUAL performance** *1981/82*
modelling paste, acrylic, oil and wax on canvas 214 × 160
the artist

52 **GEfährLICHES spiel: Praise/Insult** *1982*
acrylic, oil and epoxy on wood and canvas 242 × 175 × 16 (overall)
the artist

53 **GEfährLICHES spiel/JESTER** *1982*
acrylic, oil, fibreglass and modelling paste on wood and canvas 242 × 182 × 16 (overall)
the artist

All dimensions are given in centimetres, height before width.
Catalogue no.4 will be available for the Liverpool and Oxford showings only.

BIBLIOGRAPHY

MONOGRAPH

•Crispolti, Enrico. **Peter Phillips: Works 1960-1974.** Idea e, London, Milan and Paris, *1977.*

GENERAL REFERENCES

•Amaya, Mario. **Pop as Art: A Survey of the New Super-Realism.** Studio Vista, London, *1965.*
•Arnason, H. H. **A History of Modern Art.** Thames & Hudson, London, *1969.*
•Bowness, Alan. **Recent British Painting.** Lund Humphries, London, *1968.*
•Compton, Michael. **Pop Art.** Hamlyn, London, *1968.*
•Crispolti, Enrico. **La pop art.** Fabbri, Milan, *1966.*
•Curtis, Seng-gye Tombs, and Christopher Hunt. **The Airbrush Book: Art, History and Technique.** Orbis Publishing, London, *1980.*
•Dienst, Rolf Gunter. **Pop-Art: Eine Kritische Information.** Limes Verlag, Wiesbaden, *1965.*
•Finch, Christopher. **Image as Language - Aspects of British Art 1950-1968.** Penguin Books Ltd., Harmondsworth, Middlesex, *1969.* Chapter on Phillips.
•Finch, Christopher. **Pop Art: Object and Image.** Studio Vista, London, *1968.*
•Janis, Harriet, and Rudi Blesh. **Collage: personalities, concepts, techniques.** 2nd edition (revised). Philadelphia, Chilton Book Co., *1967.*
•Lippard, Lucy. **Pop Art.** Thames and Hudson, London, *1966.* Chapter by Lawrence Alloway, 'The Development of British Pop'.
•London. Tate Gallery. **The Tate Gallery 1968-70.** *1970.* Entry on 'Random Illusion No. 4', 1968.
•London. Tate Gallery. **The Tate Gallery 1974-6: Illustrated Catalogue of Acquisition.** *1978.* Entry on 'The Entertainment Machine', 1961.
•London. Tate Gallery. **Catalogue of the Print Collection.** *1980.*
•Naylor, Colin, and Genesis P-Orridge, editors. **Contemporary Artists.** St. James Press, London, *1977.* Entry on Phillips with text by G. S. Whittet.
•Osborne, Harold. **The Oxford Companion to Twentieth-Century Art.** Oxford University Press, Oxford, *1981.*
•Parry-Crooke, Charlotte, editor. **Contemporary British Artists.** Bergstrom & Boyle Books, London, *1979.* Entry on Phillips with partial reprint of review by Paul Overy originally published in the *Times* 16 March 1976.
•**Phaidon Dictionary of Twentieth Century Art.** Phaidon, London, *1973.*
•Pierre, José. **Pop Art: An Illustrated Dictionary.** Translated by W. J. Strachan. Eyre Methuen, London, *1977.* Entry on Phillips.
•Robertson, Bryan; John Russell; and Lord Snowdon. **Private View.** Thomas Nelson and Sons Ltd., London, *1965.*
•Russell, John, and Suzi Gablik. **Pop art redefined.** Thames and Hudson, London, *1969.*

TELEVISION

•'Pop Goes the Easel', BBC, Televised *25 March 1962.* Directed by Ken Russell and including Peter Blake, Derek Boshier and Pauline Boty as well as Peter Phillips.

CATALOGUES OF ONE-MAN EXHIBITIONS

•Zürich. Galerie Bischofberger. **Peter Phillips.** *29 April - 31 May 1967. Introduction by* Christopher Finch (reprinted in Finch, **Image as Language).**
•'Pneumatics' portfolio of screenprints, published *1968* by Bischofberger, Zürich. Introduction by Christopher Finch.
•Milan. Galleria Milano. **Peter Phillips.** Opening date *14 January 1970.* Introduction by Enrico Crispolti.
•Milan. Galleria d'arte Vinciana. **Peter Phillips.** *13 October - 11 November 1971.* Introduction by Roberto Sanesi.
•Münster. Westfälischer Kunstverein. **Peter Phillips.** *4 November - 10 December 1972.* Retrospective exhibition. Introduction by Klaus Honnef; 'On Peter Phillips' by Christopher Finch; and 'Market research produces a consumer-determined sculpture', reprinted from *Life, 20 May 1966.*
•London. Tate Gallery. **Peter Phillips's Prints.** *January - March 1976.* Leaflet by Tate Gallery Print Department with comments from the artist.

SELECTED CATALOGUES OF GROUP EXHIBITIONS

•London. Grabowski Gallery. **Image in Progress.** *15 August - 8 September 1962.* Includes statement by Phillips and essay by Jasia Reichardt, 'Towards the definition of a new image'.
•London. Whitechapel Gallery. **The New Generation: 1964.** *March - May 1964.* Includes statement by Phillips and texts by Bryan Robertson and David Thompson.
•London. Hayward Gallery. **Pop Art.** *9 July - 3 September 1969.* Introduction by John Russell and Suzi Gablik.
•Hamburg. Kunstverein. **Pop Art in England: Beginnings of a new Figuration 1947-63.** *7 February - 21 March 1976,* then travelling to Munich and York. Text on Phillips by Uwe Schneede, who contributes also a chronology and an essay, 'English Pop Art seen in Retrospect'. Essay by Frank Whitford, 'Who is this Pop? The Early Development of a Style'.
•London. Hayward Gallery. **1977 Hayward Annual.** *25 May - 4 July 1977.*

ARTICLES AND REVIEWS

•**Radio Times** *22 March 1962* 'MONITOR: Pop Art - whimsical and impudent' (with quotations from 'Pop Goes the Easel')
•**Art International** *April 1962* p. 47-48 Norbert Lynton, '"Young Contemporaries" 1962'

•**Arts Review** *21 April 1962* Michael Shepherd, 'British Painting and Sculpture Today and Yesterday'/Tooth's
•**Architectural Review** *July 1962* p.58 Robert Melville, 'Today and Yesterday'/Tooth's
•**Times** *27 July 1962* 'The Serious Side of Pop Art'
•**Metro** 7, *1962* Jasia Reichardt, 'Mail from London: Will You Be My Gorgonzola Baby?'
•**Ark** 32 *summer 1962* Richard Smith, 'New Readers start here. . .'
•**Observer** *19 August 1962* Neville Wallis, 'Private-Eye" Painters'
•**John O'London's Magazine** *30 August 1962* Charles Salling, 'Image in Progress'
•**Listener** *30 August 1962* Edward Lucie-Smith, 'Going "Pop"'
•**Studio** *October 1962* p.156 G. S. Whittet, 'Exhibition at the I.C.A.'
•**Listener** *27 December 1962* Lawrence Alloway, '"Pop Art" since 1949'
•**Viewpoint** (London) No. 2 *1962* G. S. Whittet, 'Pick of the Pops'
•**Domus** *February 1963* p.27-32 Ettore Sottsass, Jr., 'Dada, New Dada, New Realists' (review of 'New Realists' exhibition at Sidney Janis Gallery, New York)
•**Architectural Review** G. Nordland *April 1963,* p.289 Robert Melville, 'Critic's Choice at Tooth's'
•**Arts** *May 1963* p.17 '"British Art Today" organised by the San Francisco Museum'
•**Art in America** *December 1963* p.92-97 John Russell, 'England: the advantage of being thirty'
•**Sunday Times Magazine** *26 January 1964* p.14-23 David Sylvester, 'Art in a Coke Climate'
•**Quadrum** no.17 *1964* p.23-38 Robert Melville, 'English Pop Art'
•**Sunday Times** *29 March 1964* John Russell, 'The Confirmatory Push' (review of 'The New Generation: 1964')
•**Architectural Review** *June 1964* p.447-9 Robert Melville, 'New Generation 1964'/Whitechapel
•**Time** (USA) *October 1964* p.40 & 45 'Painting: Britannia's New Wave'
•**Artforum** *December 1964* Nancy Marmer, 'New British Painters'/Feigen-Palmer Gallery
•**Art in America** *April 1965* p.126-137 John Russell, 'London/NYC: the two-way traffic'
•**Aujourd'hui** *July 1965* p.75 Jasia Reichardt, 'La jeune génération en Grande Bretagne'
•**Car and Driver** *August 1965* Denise McCluggage, 'Pop Pop go the art Rodders'
•**Albright-Knox Gallery Notes** (Buffalo, New York) *Fall 1965* p.911 Samuel Clifford Miller, 'Thirty years of British art'
•**Studio International** *November 1965* p.175-183 Bruce Glaser, 'Three British Artists in New York' (three-way interview with Phillips, Allen Jones and Richard Smith)
•**Art News** *December 1965* p.17 review of Phillips exhibition at Kornblee Gallery, New York
•**Arts** *January 1966* p.66 A. G., review of Phillips exhibition at Kornblee Gallery, New York
•**Time** *29 April 1966* 'Everybody's Object' (Hybrid)
•**New Yorker** *30 April 1966* 'Hybrid'
•**Art News** *May 1966,* p.18 'Hybrid'/Kornblee Gallery
•**Arts** *May 1966* p.38-42 Lawrence Alloway, 'Hybrid'
•**Life** *20 May 1966* p.71-77 'Market research produces a consumer-determined sculpture' (reprinted in Münster retrospective catalogue, *1972*)
•**Artis** no.9 *September 1968* 'Pneumatics von Peter Phillips'
•**Art International** *November 1968* R. C. Kenedy, 'Peter Phillips' *Pneumatics'*
•**New Worlds** (London) *September 1967* p.30-34 Christopher Finch, 'Psychological Streamlining'
•**Art and Artists** *February 1968* p.20-23 Christopher Finch, 'Communicators'
•**Art International** *20 April 1968* Christopher Finch, 'Peter Phillips'
•**Architectural Review** *July 1968* p.61 Robert Melville, 'Young Consolidators: the "Interim" show at Whitechapel'
•**Artis** no.9 *September 1968* 'Pneumatics von Peter Phillips'
•**Art International** *November 1968* R. C. Kenedy, 'Peter Phillips' *Pneumatics'*
•**Mizue** (Tokyo) *August 1970* p.65-79 'Peter Phillips'
•**Art Now** (Kodansha, Tokyo) vol.5, 6, 10, *1971-72*
•**Studio International** *October 1971* Mark Glazebrook, 'Peter Phillips at the Whitechapel' (Letter to the Editor)
•**Munsterischer Anzeiger** *4 November 1972* 'Ein Mann und sein Gürtel'
•**Munstersche Zeitung** *6 November 1972* Hermann Lober, 'Kalte Bilderwelt der Pop-art'
•**Die Welt** *23 November 1972* Axel Hecht, 'Die Realität am Mischpult: Bilder des englischen Pop-Artisten Peter Phillips im Westfälischen Kunstverein'
•**Dusseldorfe Nachrichten** *3 January 1973* Klaus Reinke, 'Die Pop-Art stammt aus England: Retrospektive Peter Phillips im Westfälischen Kunstverein'
•**Control Magazine** (UK) no.8 *August 1974* p.15 Gerald Laing, 'Hybrid'
•**Arts Review** *23 January 1976* p.38 Eddie Wolfram, 'Peter Phillips Prints'/Tate Gallery
•**Times** *16 March 1976* Paul Overy, 'The Philosophy of the simultaneous' (Peter Phillips/Waddington Galleries)
•**Spectator** *27 March 1976* John McEwen, 'Between the lines'
•**Observer** *28 March 1976* Nigel Gosling, review of Peter Phillips exhibition at Waddington Galleries
•**Arts Review** *2 April 1976* p.158 Harold Osborne, 'Peter Phillips'/Waddington Galleries II
•**Art International** *April-May 1976* p.21-5, R. J. Oronato, 'The Modern Maze'
•**Art News** *May 1976* p.105 review of Peter Phillips exhibition at Waddington Galleries
•**Times** *2 June 1976* Paul Overy, 'Superstars for a day: the rise of Pop art in England'
•**Architectural Review** *June 1976* p.378 review of Peter Phillips exhibition at Waddington Galleries
•**Art International** *summer 1976* Fenella Crichton, review of Peter Phillips exhibition at Waddington Galleries
•**Art & Artists** *August 1976* p.17 Tony del Renzio, 'Pop' (review of 'Pop Art in England' exhibition)
•**Art International** *summer 1976* p.17-18 review of Peter Phillips exhibition at Waddington Galleries
•**New Sounds New Styles** *May 1982* Marco Livingstone, 'Peter Phillips'

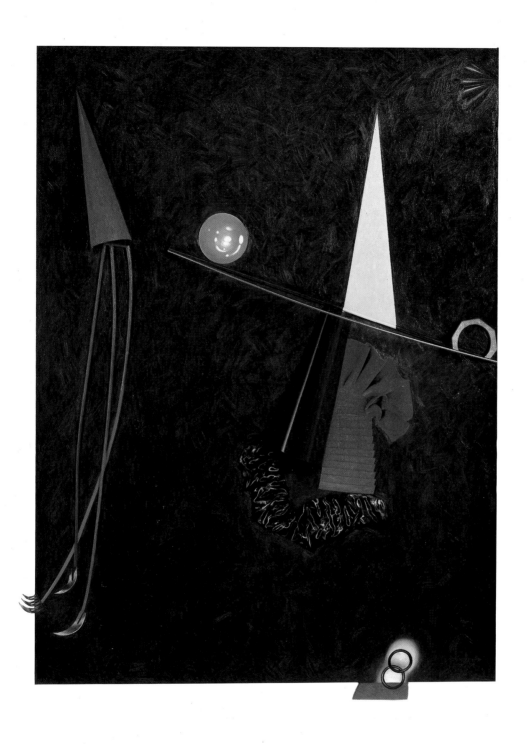

GEfährLICHES spiel/JESTER *1982*
acrylic, oil, fibreglass and modelling paste on wood and canvas
242 × 182 × 16 (overall)
the artist *(cat. 53)*